The Life of Forms in Art

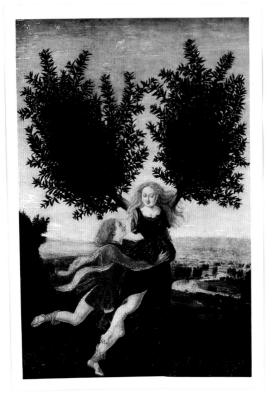

Pollaiuolo: Apollo and Daphne

The Life of Forms in Art

Henri Focillon

ZONE BOOKS · NEW YORK

1989

This edition © 1989 Urzone, Inc.
ZONE BOOKS
611 Broadway, Suite 838
New York, NY 10012

Originally published in 1934 as *La vie des formes*,
© Presses Universitaires de France. The introduction
is © Jean Molino and originally appeared in *Henri
Focillon*, collection *Cahiers pour un temps*, Edition du
Centre Pompidou, Paris, 1986.

Printed in the United States of America.

Distributed by The MIT Press,
Cambridge, Massachusetts and London, England

Library of Congress Cataloging-in-Publication Data

Focillon, Henri, 1881-1943.
 [Vie des formes. English]
 The life of forms / Henri Focillon : translated by
 Charles B. Hogan and George Kubler.
 p. cm.
 Translation of: Vie des formes.
 Reprint. Originally published: New York :
 Wittenborn, Schultz, 1948.
 1. Form (Aesthetics) 2. Form (Philosophy) 3. Hand.
 I. Title.
 ISBN 0-942299-56-6 (alk. paper)
 0-942299-57-4 (pbk.)
 BH301.F6F613 1989 701'.8 — DC19 88-20598 CIP

Contents

Translators' Foreword

The *Vie des formes* was originally published in Paris in 1934. Since then there has been another French edition, and translations into Czech and Danish, although the latter exists only in manuscript. The present text is the first to appear in English.

When work upon it was begun, its distinguished author granted to the translators an entirely free hand. Their text is, as a result of this generous action, somewhat longer than is that of the original, since a great many words and passages have been liberally extended. No translation is — or at least should be — strictly literal. This is peculiarly the case as regards a book whose argument is as penetrating and as revolutionary as is that of the *Vie des formes*. Every effort has therefore been made to keep the text as explicit as possible, without at the same time transgressing the field that belongs rightfully to the critic or the interpreter.

But the experience of working on the text has been made doubly advantageous and doubly valuable to the translators by the experience of working with the author. M. Focillon's patience, his criticisms and elucidations, loom very large upon the horizon of their endeavors. It could be said with little exaggeration that he not only wrote the book, but is rather more than half responsible for its English dress. To Mme. Focillon, too, the trans-

lators owe a heavy debt of gratitude. Her wonderfully idiomatic knowledge of English has stood more than one thorny passage of the French in good stead. Not one of the following pages is without its mark of her suggestion or elucidation.

An evasion of responsibility may seem, here, to be implied, but it is not intended. The *Vie des formes* is, be it frankly said, by no means an easy book to read, nor was it an easy one to translate. For the inadequacies of style, the shortening of certain phrases and the amplifying of others, the still-remaining deposits of gallicisms – in short, for whatever is unsatisfactory, the translators are in every instance to blame.

Special thanks are due to S.L. Faison, Jr. who translated "In Praise of Hands." Mr. Emerson Tuttle and Mr. Robert Bates have made many pertinent suggestions and have given cheerful and attentive assistance in the unraveling of difficult passages. Mr. George Hamilton's criticism of the manuscript as a whole was so percipient that, of the scores of recommendations he made, all but two or three were immediately adopted.

<div align="right">

CHARLES BEECHER HOGAN
GEORGE KUBLER

</div>

Introduction

by Jean Molino

En el central reposo se cierne el movimiento.
<div style="text-align: right">— Miguel Hernández</div>

The Life of Forms in Art is an unusual book, and one that initially might seem to hold little interest for the contemporary reader. Well written, perhaps even too well written — since this is not seen as a gauge of scientific rigor — the book uses a somewhat supple rhetoric to reflect on problems of art and art history. It contains few or no concepts, no specific theory, no simple analytical model comparable to Panofsky's iconologic program, no experimental or philosophical aesthetic. And yet, *The Life of Forms in Art* is one of that small number of books in which a lifetime's experience is collected and in which we find in condensed form a great specialist's global vision of his field of study.

Great historians are rarely theoreticians: their sense of the complexity of things means that they feel at ease only with specific problems, particular areas of inquiry. Focillon is one of those thinkers who are too attached to matter to isolate its abstract forms, to formulate a diagram, a generic model that could then simply be applied to all possible cases. Focillon has no explicit theory of art or art history to offer us, because he feels that no theory, no model has universal value. Does this mean that he has no analytical tools, no principles to guide him in his research? Certainly not, but his principles and tools are adaptable and com-

plex, and can always be modified on contact with the object of analysis. It is precisely this quality that gives *The Life of Forms in Art* its value, this book in which Focillon went as far as he could, as far as he wanted to, in the direction of abstraction and of theory. But flexible and open models are no less useful and illuminating than the rigorous and too simple models produced by a Formalist age. This is especially true when the flexibility is in the service of a central hypothesis that animates the entire work: form is alive.

We must be careful not to interpret the title and this central thesis erroneously: what is important here is not the biological metaphor according to which forms constitute living organisms whose evolutionary laws would then be the same as those of animals. I see no trace of organicism in Focillon's thought, which does not make form a living organism so much as life itself a form; this is the meaning of Balzac's pronouncement that is quoted at the beginning of the book: "Everything is form, and life itself is form." Why then speak of the life of forms? The title, as Focillon points out, echoes that of Darmsteter's famous work, *The Life of Words*, and I will come back to the parallelism thus proposed between language and plastic forms. But the point, for Focillon, is not merely to situate himself in the context of historicism according to which, at the end of the nineteenth century, historical linguistics, literary history and art history all came together. It is true that he is above all a historian, and faithful to the historical method that reigns in all disciplines. It is here, however, that the choice of title is significant, since it refers not to the history of forms, but to their life. Focillon remains removed from formalisms like the iconologies of the Warburg School, and it is doubtless because of his distance from such movements that he is now beyond them and still has much to tell us. And what he says is that form is inseparable from movement: forms are alive

in that they are never immobile. Recent orientations in the anal-
ysis of artistic works have tended to privilege figures and signifi-
cations. Focillon reminds us that figure and significations are
caught in a perpetual movement:

> Plastic forms offer peculiarities that are no less remarkable....
> Such forms constitute an order of existence and ... this order
> has the motion and the breath of life. Plastic forms are sub-
> jected to the principle of metamorphoses, by which they are
> perpetually renewed....

Life and metamorphosis do not merely have a historical dimen-
sion; they characterize forms in all circumstances, and the imme-
diately perceived form takes on movement, is already movement:

> For form is surrounded by a certain aura: although it is our
> most strict definition of space, it also suggests to us the exist-
> ence of other forms. It prolongs and diffuses itself through-
> out our dreams and fancies: we regard it, as it were, as a
> kind of fissure through which crowds of images aspiring
> to birth may be introduced into some indefinite realm — a
> realm which is neither that of physical extent nor that of
> pure thought.

How could our era, which is that of dynamic art, of art as event,
not be in agreement with Focillon in his recognition, at the heart
of form, of movement?

Form constitutes a specific domain. It "sets up within history an
immutable order," an autonomous reality that presents itself as a
"fourth realm" added to the three realms of the physical world.

Borrowing Popper's formulation, one could say that forms belong to "World 3," the world of human knowledge that includes the objective content of thought set down and inscribed in objects and material traces, writing, buildings, paintings and sculptures. But we should probably not be too hasty in placing all human productions in which thought is incarnated under a single heading; let us first of all deal with artistic forms in terms of their singularity, before mixing them together or putting them with other types of human expression.

It cannot be denied that there is a whole world of artistic forms. Certainly, the relativisms and sociologisms currently in fashion have always sought to contest the existence of a world of artistic forms. Art, it is endlessly repeated, is not a pure and atemporal essence, and an autonomous world of art only gradually became separated from the other spheres of social life; Egyptian art is not art, any more than is Roman sculpture; these are religious objects and realities, for which form is hardly more than embroidery, an ornament added to function, almost as an afterthought. It is only to us, twentieth-century aesthetes, that an Aurignacian sculpture has come to represent Venus; for prehistoric people it was only an image of fertility that doubtless had its place in rites and myths of a religious order. These received ideas I have just mentioned are quite simply false: artistic and aesthetic categories are not a recent invention, they correspond to a basic anthropological given: there is no human group without some form of artistic expression. This does not mean that art is separate, but that artistic judgment can be associated with other modes of perception and of judgment, and association means neither confusion nor identification. Steven Feld's admirable work, *Sound and Sentiment*, shows that the Kaluli of New Guinea are capable, in a religious ceremony, of making specifically aesthetic judgments about the songs they hear: religious fervor does not preclude artis-

tic perception. Art is thus an anthropological category.[1]Also, according to Pierre Francastel's strict formulation: "A recognition of the character of artistic emotion as being absolute and common to all humanity links the Beautiful not to an established model but to the exercise of a primordial faculty of the species."[2] This anthropological foundation is alone capable of guaranteeing the autonomy of the world of forms described by Focillon.

We can now begin to understand why this world of forms cannot be caused or explained by anything other than itself. To make this clear, Focillon goes back to Taine's doctrine, which he discusses at length. Is it worthwhile discussing Taine today, was it worthwhile when Focillon was writing *The Life of Forms in Art*? I think so, since even if contemporary sociologists of art do not like to be associated with Taine's work, they must nonetheless recognize that they are his direct heirs. And the fundamental, the unanswerable objection, now as before, to all sociological reductionisms, is magnificently expressed by Focillon in a single sentence: "The most attentive study of the most homogeneous milieu, of the most closely woven concatenation of circumstances, will not serve to give us the design of the towers of Laon."

Let us briefly examine this argument, which, in this form, may appear to be obvious, banal. But it is precisely this obvious banality that all the sociologisms seek to obscure: an infinite number of historical, cultural and economic meditations can be amassed around a form, but those meditations will never give us that form, nor for that matter any other form. Unless, of course, the meditations are themselves, at least in part, formal: the commercial

1. Steven Feld, *Sound and Sentiment* (Chicago: Chicago University Press, 1982).

2. Pierre Francastel, "Esthétique et ethnologie," in J. Poirier, *Ethnologie générale* (Paris: Gallimard, 1968), p. 1707.

relations between East and West "explain" Romanesque decor insofar as those relations encouraged the exchange of forms; social and economic conditions may encourage the spreading of a style, but they cannot explain its formal elements or their evolution. Taking form in its simplest expression, the line, what factors, what reflections could account for the line, for the interlacements in Irish manuscripts, for the ornamental calligraphy of Islamic art, for the lines of Matisse and Ingres, Harunobu or Kiyonaga? The objection will no doubt be raised that the prohibition of figurative representation explains Islamic ornament; in reality, this formula is misleading, since the prohibition does not explain the unique patterns, which could not be confused with anything else; the interlacements in the Book of Kells do not belong to the same family as the arabesques of Mchatta. Nothing explains the genesis of forms, nothing, that is, except forms themselves and their encounters with other forms.

Neither race — hardly a fashionable notion — nor milieu could produce a form; can we find the last element of Taine's triptych more useful? Beneath a word whose colors have faded hides an analytical model that is quite alive:

> At first glance it would seem that we are here touching on the very essence of the relationship between art and history. If so, art would appear to be a most remarkable series of purely chronological happenings, similar to the transposition into space of a whole gamut of far-reaching actualities.

We have here, framed in another vocabulary, the idea of a culture's unique expressivity, that can be found in Spengler, Panofsky or Foucault: the products of a single culture at a single moment

harmonize "in a profound and shadowy unity," secretly tuned monads that express, each in its own way, a single meaningful content, a single spirit of the times. Focillon's reply to this is the following:

> We have no right to confuse the state of the life of forms with the state of social life. The time that gives support to a work of art does not give definition either to its principle or to its specific form.

This moment in which the artist is situated is neither single nor homogenous: How could Raphael's form be *the* product of his culture, if "his time held out to him the most diverse images, the most flagrant contradictions?" There is moreover an individual genesis of form that is largely independent of the rhythm of culture: "The history of form in Raphael — whose life we have come to look on as a model of perfect happiness — reveals serious crises." The notion of the "moment" is all the more inexact, all the more misleading, in that it is based on a confusion of form and taste, while "the moment of a work of art is not necessarily the moment of taste." And taste itself, the love of art or the desire to stand out, is it under the sway of social determinism? "It may freely be admitted that the history of taste faithfully reflects sociological conditions, providing we introduce those imponderables, such as the altogether fantastic element of fashion, that modify whatever they touch." I would tend to be less affirmative than Focillon, who, in any case, takes back a great deal of what he has just granted by introducing the "fantastic" world of fashion. In fact, fashion plays the same role as the work of art in terms of taste: both follow it, remain in tune with it, but just as often create it; form is, "at the very instant of its birth, a phenomenon of rupture." The moment is a complex situation, in which multi-

ple orientations and divers polarities are placed side by side, meet and collide, and in the midst of which those ruptures occur that are called events. We thus come to the idea of multiple temporalities, of a layered temporality in which each domain, each level of historical reality advances according to its own rhythm and largely independent of the rhythm of other domains. "We may in this wise be led to observe a sort of mobile structure of time that displays, in accordance with the diversity of movement, many different kinds of relationships." In this way, Focillon brings us to a history with many voices, in which artistic form has its place in the same way as society or economy: "All these families, environments and events that are called forth by the life of forms act in their turn on the life of forms itself, as well as on strictly historical life."

There exists, then, a world of artistic forms; but what is a form? The first move is, if not to define it, at least to see the model for it in contour or diagram, the shadow thrown by a body exposed to the sun, the play of cracks and fissures on the wall where Leonardo saw warriors and clouds take on outlines. These are certainly dangerous examples, ones that suggest a far too intellectual interpretation of form, which appears only after a lengthy development. Form, in its origins as in its most general signification, is other and more than contour. Nothing could more amply confirm Focillon's analysis than the point of view more recently put forth by Leroi-Gourhan in his reflections on the paleontology of symbols. In order to confirm that artistic forms constitute an autonomous domain, it is necessary, as we have already seen, to go back to an anthropological foundation:

This code of aesthetic emotions, based on biological properties common to all living creatures, is that of the senses which afford a perception of values and rhythms, or more generally still, from the simplest invertebrates on, a reflexive participation in rhythms and a reaction to variations in values.[3]

Form is therefore not primarily line and color, it is a dynamic organization that brings into play the concrete texture of the world as the sum of the body's reactions to that which surrounds it.

Form is not manifested in the guise of a border separating existing objects; it engenders the environment in which objects exist:

A work of art is situated in space. But it will not do to say it simply exists in space: a work of art treats space according to its own needs, defines space and even creates such space as may be necessary to it.

What prevents us from being aware of this is the naive faith that we, in the post-Renaissance West, have in Albertian perspective, which has been unduly assimilated into the real, although the "natural" perspective of the Renaissance is only one symbolic construction among others. As we know, perceived space is not Euclidean, and formerly the view was held that binocular visual space was Lobachevskian space with a negative curve; the problem is that space as lived and perceived is the unstable result of relations that exist at a given moment between a subject and its environment: if those relations change, the modalities of per-

3. A. Leroi-Gourhan, *Le geste et la parole: La mémoire et les rythmes* (Paris: Albin Michel, 1965), p. 82.

ceived space will change as well. Space appears as multiple and complex from whatever aspect one approaches it. There is no sensory space, but rather polysensory space, since there are auditory space and tactile space as well as visual space. In the same way, as Focillon points out, there is no single artistic space in which all forms could be found:

> Form is not indiscriminately architecture, sculpture or painting. Whatever exchanges may be made between techniques — however decisive the authority of one over the others — form is qualified above all else by the specific realms in which it develops, and not simply by an act of reason on our part, a wish to see form develop regardless of circumstances.

This statement is entirely valid even for the most apparently simple form, the elementary motif made into ornamental theme:

> Not only does it exist in and of itself, but it also shapes its own environment — to which it imparts a form. If we will follow the metamorphoses of this form, if we will study not merely its axes and its armature, but everything else that it may include within its own particular framework, we will then see before us an entire universe that is partitioned off into an infinite variety of blocks of space.

It is here that form is not simply perceived, but also constructed, an artifact containing all the modalities of perceived space but that at the same time constructs an analogue of that space, and in which irreducibly new spatial modalities come into being: in the geometric combinations of Islamic art, "a sort of fever seems to goad on and to multiply the shapes; some mysterious genius

of complication interlocks, enfolds, disorganizes and reorganizes the entire labyrinth."

Form in space is also an abstraction, since it is separated from matter, which is what lends it body:

> Unless and until it actually exists in matter, form is little better than a vista of the mind, a mere speculation on a space that has been reduced to geometrical intelligibility.... In spite of certain illusions popularly held in regard to it, art is not simply a kind of fantastic geometry, or even a kind of particularly complex topology. Art is bound to weight, density, light and color.

Contemporary art, if it has not made us more conscious of the importance of matter, has at least displayed its relative autonomy in terms of spatial form. We must not, however, in once more taking up the form–matter opposition, see matter as a passive given that is there to organize form, "for it is plainly observable how matter imposes its own form upon form." Once again to take the simplest case: in drawing, it would seem that the material is on the verge of disappearing, and yet what a difference is made by paper, its color and texture, and by the special qualities of the instrument – Conté crayon, chalk, ink or graphite:

> To be satisfied as to this, one need only imagine any such impossibility as... a charcoal drawing copied in wash. The latter at once assumes totally unexpected properties; it becomes, indeed, a new work.

It is therefore appropriate to renounce the old philosophical opposition between form and matter: matter is not passive, it is active, and the finished work is born of an incessant exchange

between matter and form. This dialectic can nowhere be seen more clearly than in the genesis of the work of art, in the activity that gives rise to it, traces of which remain in sketches, drafts, plans and abandoned projects. Here matter is incarnated in technique: clay cannot be sculpted like stone or marble, one does not paint with watercolor as with oil.

We have thus gone from the work of art to the activity that produces it. It is true that the work only exists as such insofar as all links attaching it to its creator have been severed: "In other words, a work of art is not the outline or the graph of art as an activity; it is art itself. It does not design art; it creates it." And yet, the work always retains a reference, potential but indispensable, to the human activity that has produced it, just as it contains an appeal — however potential it may be — to the activity of the subject who will one day perceive it. It is doubtless here that we can find the secret of the singular mode of existence that characterizes the work of art, like all human productions: an object among the world's objects, the art object is distinct from others because of the double relation of production and reception that links it to humanity, artist and viewer. Karl Popper and John Eccles have recently attempted to account for the cultural world's paradoxical status by making it a "Third World," the world of the symbolic, distinct from the "First World" or physical world and linked to it by the "Second World" or sphere of subjective experience.[4] A work of art is the record of an activity that has been in a way set down or incarnated, and which is constantly awaiting reactivation; if form is taken as a static reality, then a work of art is not form but a plan of activity, form inhabited by a tension, a dynamism that lines it and animates it from within.

4. Karl Popper and John Eccles, *The Self and Its Brain* (New York: Springer-Verlag, 1978).

This movement inscribed in the work of art would then seem to be produced by the activity of thought. Is not form carried along by the dynamism of signification? It is on this point that Focillon's reflections are essential, for they show us that form must be separated from signification, or rather from all other signification than the purely formal: "form signifies only itself."

Let us attempt to understand and to pinpoint this elusive relationship between form and signification. Within the framework of contemporary semiologies, which constantly attempt to define the association of signifier and signified, form without signification is inconceivable, signification being then considered as not formal. Focillon, however, affirms that "the fundamental content of form is a *formal* content." Three or four species of the genus "sign" are generally distinguished, taken in its largest sense: the index, the sign in its strict sense, the icon and the symbol. What these different species have in common is the presence, behind and beyond the sign's material aspect, of a signifying aspect: clouds announce rain, a portrait refers to a model, the sign transmits signification, the symbol gives rise to a signified that cannot be apprehended directly by thought. Artistic form is not, however, index, sign, icon or symbol; it can become any of these things, perhaps even unceasingly is, but signification is joined to form as an unnecessary addition. Being symbolic animals, human beings lend signification to everything around them and, above all, to the products of their own activity. But in the case of the artistic work, which is form, symbolization is constituted in a nonconceptual mode, because it is in relation to the activity of the subject, an activity of perception or of fabrication. The meaning of form is above all the rhythm of the body, the movement of the hand, the curve of the gesture. It is only at a second stage that the various levels of conceptual signification become articulated and attached to form.

Form signifies itself, as Focillon put it; that is to say, if all sig-
nification entails allusion, then it alludes to something other than
itself, but that something is, above all, form. This allusion of form
to form is nowhere more apparent than in the dialectic that has
brought together, all through the history of art, the two great
types of form, living forms and abstract forms. In the earliest
Romanesque sculpture, Focillon tells us, "ornamental figures and
human beings can be superimposed"[5]: the contours of the body
are at the same time arcs, capitals and bases constructed accord-
ing to a complex play of circles, curves and triangles. Such fusion
and ambiguity are rarely as complete as in early Roman art, but
the same interplay between geometric and mimetic figures is to
be found everywhere:

> The mathematicians in the *School of Athens*, the soldiers in the
> *Massacre of the Innocents*, the fishermen in the *Miracle of the
> Fishes*, Imperia seated at the feet of Apollo or kneeling before
> Christ — all these are the successive interlaces of a formal
> thought composed of and supported by the human body, and
> by means of which are contrived symmetries, contrappostos
> and alternating rhythms.

There are doubtless, from the first outlines of artistic production,
two kinds of form, which are already in coexistence in prehistoric
cave art, with its "naturalistic" animals and geometric symbols.
Borrowing a term from Wilhelm Worringer, we may call them or-
ganic and crystalline or abstract forms.[6] They give rise to the two
great orientations in art, representational and abstract or ornamen-
tal art; but the essential point is that neither of the two species,

5. Henri Focillon, *The Art of the West, Volume 1* (London: Phaidon, 1963), p. 105.
6. Wilhelm Worringer, *Abstraktion und Einfühlung*, 1908.

22

with whatever purity it is realized, can help alluding to the other.

We can thus better understand the very particular significa-
tion that is attached to form, and to what extent it is distinct from
conceptual signification as manifested in language. This point
should be stressed, since, even more than artistic creation, criti-
cism and art history have fallen prey to a dangerous deformation,
which consists in linking art and conceptual thought much too
closely. *The Life of Forms in Art* implicitly provides the ingredi-
ents of a critique of iconology, if that word can be taken not
merely as the discipline put forth by Panofsky, but also to include
all reductions of art to conceptual content. Let us begin with
Focillon's decisive formula:

> Iconography may be understood in several different ways. It
> is either the variation of forms on the same meaning, or the
> variation of meanings on the same form. Either method sheds
> equal light on the respective independence of these two terms.

Even a representative form does not have one meaning, because
it has several, or it has none, which comes down to the same
thing — I mean no conceptual meaning that would of necessity
be attached to it. Iconography in its strict sense must be clearly
distinguished from iconology; iconography, insofar as it helps us
to identify a scene or a figure, says nothing of its signification,
or, if signification can be a useful term in this context, it would
seem that iconography gives us no more than an identity card, a
police record. All of our difficulties begin at the moment at
which we try to relate the signification that an iconological theme
might evoke in a given culture, and the forms in which, *hic et
nunc*, that theme is incarnated. What does Michelangelo's *David*
"mean"? If I relate it to the 1494 Hercules, which was itself
inspired by the ancient models of Hercules found on sarcophagi,

I allude from one form to another form. At the same time, certainly, David is metaphorized as Hercules: an aura of more or less vague significations envelops the form but does not constitute any meaning. It is true that the David-Hercules is the "*cittadino guerriero*" in whom civic virtues are incarnated, but this global signification is only a form-derived meaning insofar as the conceptual signification has given rise to formal consequences. Nothing seems to me more ambiguous and more dangerous than the currently popular notion of "iconographic program." The study of the Italian Renaissance, in which philosophical thought is more or less closely tied to artistic creation, and the development of the history of ideas, have helped to displace the center of gravity of the artistic phenomenon by eliminating the border between formal fact and fact of conceptual signification. It is interesting to know that Michelangelo was influenced by neoplatonism, but the essential problem is to know whether and how neoplatonic culture gave rise to a formal choice. If not, we run the risk of being led to describe the work as an allegory, as a group of conceptual significations directly expressed by the forms that correspond to them. It is at this point that we must heed the lesson offered us by art history, the engraver's son Henri Focillon and the Thomist philosopher Etienne Gilson, who are always conscious of being as creation, of being as irreducible to any essence and to any signification: to create is not to know, and art depends only indirectly on knowledge. A philosophical stance or a constellation of ideas can certainly guide and accompany the artist; such knowledge is not for him simply ideas, but ideas that are immediately attached to forms, and these forms follow one another according to relationships that are, above all, formal. Rather than seeing ideas as giving rise to forms, we must recognize that they color them, that they surround them without ever creating them. This is also, if we interpret him correctly, the lesson offered by

the painter who was doubtless the most "intellectual" artist of all time, Leonardo da Vinci. For him, painting is "*cosa mentale*," but the theoretician's knowledge has the infinite diversity of natural forms as its point of departure and point of arrival:

> Knowing, painter, that in order to be excellent you must have a universal ability to represent all aspects of forms produced in nature, you would not know how to do it without seeing them and taking them into your mind.[7]

Painting is an intellectual activity because perception is an intellectual activity, as is imagination; but both are based on the existence, the creation and the recreation of visible forms.

There are then, really, two significations that adhere to form: a specifically formal signification that is allusion to other forms, and a nonformal signification, without a doubt always present, but whose relation to form is largely arbitrary. We are thus led, in keeping with Focillon's suggestions, to reverse the links between plastic forms and language: iconology brings the signification of form back to a meaning analogous to that which characterizes the linguistic sign. Focillon demonstrates that it is perhaps necessary to interpret linguistic signs in the light shed by artistic form. There is a life of words comparable to the life of forms, and they both underline the "relative independence of the two terms," form and signification, signifier and signified: the words change meaning and the meanings change words. The linguistic signifier is certainly form, and it thus obeys the general laws of forms:

> The sign bears general significance, but having attained form,

7. Leonardo da Vinci, *La peinture*, introduced by Andre Chastel (Paris: Hermann, 1964), p. 43.

it strives to bear its own individual significance; it creates its own new meaning; it seeks its new content, and then endows that content with fresh associations by the dislocation of familiar verbal molds.

What is true for the aesthetic usage of language is also true in current usage where "the verbal sign can become the mold for many different interpretations and, having attained form, experience many remarkable adventures," thanks to "a hidden travail from which spring forms that are untouched and uninfluenced by any of the fickle changes of meaning."

All is therefore movement around form, movement of non-formal significations that are added to a work, but also and above all movements of forms themselves. In order to talk about form, one must also specify that forms are caught in a perpetual metamorphosis; since there is no meaning without displacement of meaning, without metaphor, there is no form without change of form, without metamorphosis: "Plastic forms are subjected to the principle of metamorphoses, by which they are perpetually renewed...." If, within the framework of a general semiology, signification is defined as allusion or reference — a reference of one sign to another, from which an infinity of meanings is born — we can therefore rightly speak of formal signification. Here too, signification is reference, of one form to other forms, in the mind and hand of the one who creates, in the contemplation of the one who looks, in the historical succession that makes forms follow one another. Form is perpetual movement: "In reality, it is born of change, and it leads on to other changes."

For the creator, there is no form without movement. This is primarily because artistic creation, like all creation, is production about and based on the forms transmitted by tradition; the artist stores inherited forms and elaborates his or her own forms

in a dialogue with forms from the past. As a result, these new forms bear the trace, the multiple traces, of the old forms among which they take their place. At the same time, however, the finished work is always only the provisionally definitive version of a series that is in theory infinite, a series of which we are acquainted with several elements thanks to drafts and sketches.

> Within the same shape there are often many such changes, as in the preliminary sketches of painters who, seeking the accuracy or the exact beauty of a movement, will superimpose the drawing of several arms on the same shoulder. Rembrandt's sketches swarm across Rembrandt's paintings. The rough draft always gives vitality to the masterpiece.

All is form in the creator's mind, including the various modalities of emotional life:

> I do not say that form is the allegory or the symbol of feeling, but rather, its innermost activity. Form activates feeling. Let us say... that art not only clothes sensibility with a form, but that art also awakens form in sensibility.

For the artist as for the writer, sentiment is form:

> O memories! O horrible form of the hills![8]

The work of art also moves for the viewer, who only sees and recognizes form against the background of the other forms that con-

8. Victor Hugo, *A celle qui est restée en France.*

stitute his or her imaginary museum. Aesthetic contemplation is not a pure presence, the immediate revelation of a finality without end; if form is pleasing without concept, that is because it is a dialogue of forms, forms offered by the work of art and forms present in the viewing eye.

Separated from its creator and from its potential viewers, the work of art "is motionless only in appearance." It is caught up in the movement that carries it from change to change and constitutes its history. This history, as we have seen, is autonomous, and must not be violated by insertion into a general history in which some rational being, some spirit of the times, is supposed to account for all the products of an age in a given culture. What we urgently must know is which tools we have at our disposal to understand the life of forms. Focillon reminds us of some of the models that can help us to describe and to interpret changes in forms. There are logical models, according to which a style "takes shape and exists as such only by virtue of the development of an internal logic, of a dialectic worth nothing except in relation to itself."

Such a model would seem to be quite appropriate to the development of an ornamental style; this has been applied to Gothic architecture, "considered as the development of a theorem," not only in the context of speculation, but "in its ordinary historical activity." This conception, however, according to Focillon, underestimates the importance of the real process that alone is capable of accounting for this apparent logic:

> It would be a mistake, however, not to recognize in this graph the action of an *experiment* at each of its crucial points. By experiment I mean an investigation that is supported by prior knowledge, based on a hypothesis, conducted with intelligent reason and carried out in the realm of technique. In this sense it may well be said that Gothic architecture is guesswork

and reasoning, empirical research and inner logic all at once.

One could even say that Focillon proposes a "Popperian" conception of the life of forms: there is an experimental logic of forms, in which problems, hypotheses, attempts, errors and solutions succeed and entail each other in order to yield new problems. There is, I believe, no other path leading to a theory of symbolic forms and of their history.

Let us examine in conclusion a last hypothesis of Focillon's, the "law of four states" that is hardly fashionable today but which we should reconsider, for, despite appearances, it has much to teach us:

> Each style passes through several ages and several phases of being. This does not mean that the ages of style and the ages of mankind are the same thing. The life of forms is not the result of chance. Nor is it a great cyclorama neatly fitted into the theater of history and called into being by historical necessities. No. Forms obey their own rules — rules that are inherent in the forms themselves, or better, in the regions of the mind where they are located and centered — and there is no reason why we should not undertake an investigation of how these great ensembles, united by close reasoning and by coherent experiment, behave throughout the phases that we call their life. The successive states through which they pass are more or less lengthy, more or less intense, according to the style itself: the experimental age, the classic age, the age of refinement, the baroque age.

There is no great liking these days for large evolutionary schemes,

and this law of the four states of style occupies approximately the same status as the evolutionary model proposed by Toynbee. I think, however, that both are regarded with suspicion for bad reasons and, in the first place, because we do not seem able to abandon linear conceptions of cultural evolution. Even catastrophist models — like that of Foucault, who sees a succession of cultural worlds separated by unbridgeable schisms — are incompatible with any idea of evolution that is at all cyclical, with the idea of an Eternal Return of the analogous, if not of the same. Without entering into the discussion of a problem that would take us too far off our track, let us simply ask one question: Why should there not be regularities in the evolution of styles as in the evolution of cultures? There is certainly something to be explained in that familial air displayed by states of style lacking any historical relation.

These distinctions are perhaps not wholly new, but it must be borne in mind that — as Waldemar Déonna has pointed out in a penetrating analysis of certain epochs in the history of art — these ages or states present the same formal characteristics at every epoch and in every environment. This is so unmistakably the case that we need not be surprised in noting the close similarities between Greek archaism and Gothic archaism, between Greek art of the fifth century B.C. and the sculptures of the first half of the thirteenth century A.D., between the flamboyant, or baroque state of Gothic, and eighteenth-century rococo art.

Why should movement itself not have a form?

Translated by Elizabeth Ladenson

The World of Forms

Whenever we attempt to interpret a work of art, we are at once confronted with problems that are as perplexing as they are contradictory. A work of art is an attempt to express something that is unique, it is an affirmation of something that is whole, complete, absolute. But it is likewise an integral part of a system of highly complex relationships. A work of art results from an altogether independent activity; it is the translation of a free and exalted dream. But flowing together within it the energies of many civilizations may be plainly discerned. And a work of art is (to hold for the moment to an obvious contradiction) both matter and mind, both form and content.

Again, the critic will define a work of art by following the needs of his own individual nature and the particular objectives of his research. But the creator of a work of art regards his work – whenever he takes the time to do so – from a standpoint very different from that taken by the critic, and should he chance to use the same language in speaking of it, he does so in quite another sense. And the lover of a work of art – that is, the man of true sensitivity and wisdom – loves it for itself alone, wholeheartedly. In his unshakable belief that he may seize hold of it and possess its very essence, he weaves about it the mesh of his

inmost dreams. A work of art is immersed in the whirlpool of time; and it belongs to eternity. A work of art is specific, local, individual; and it is our brightest token of universality. A work of art rises proudly above any interpretation we may see fit to give it; and, although it serves to illustrate history, man and the world itself, it goes further than this: it creates man, creates the world and sets up within history an immutable order.

From the above it is easy to see how luxuriant is the wilderness of criticism that may spring up beside a work of art: flowers of interpretation that do not adorn, but completely conceal. And yet one of the very essentials of its character is the welcome it holds out to all possible interpretations, which may be — who can tell? — already commingled within it. Here, in any event, is one obvious aspect of the immortality of a work of art; here, if the expression may be allowed, is the eternity of its present, the proof of its human abundance and of its inexhaustible interest. And yet, we must not forget that the more a work of art is used for any specific purpose, the more is it despoiled of its ancient dignity, and the more is its privilege of working miracles revoked. How best can we define something that lies so far beyond the reach of time and yet is subjected to time? Is this prodigy merely a simple phenomenon of cultural activity in a chapter of general history? Or is it something added to our universe — an entirely new universe, with its own laws, materials and development, with its own physics, chemistry and biology, with its own engendering of a separate humanity? To find the answers to these questions, to pursue, in other words, the study of a work of art, we must, for the time being, isolate it. Then and only then would we have the opportunity of learning to *see* it. For art is made primarily for sight. Space is its realm — not the space of everyday life involving, say, a soldier or a tourist — but space treated by a technique that may be defined as matter and as movement. A work of art is

the measure of space. It is form, and as form it must first make itself known to us.

In one of his political tracts, Balzac has affirmed that "everything is form, and life itself is form." Not only may every activity be comprehended and defined to the extent that it assumes form and inscribes its graph in space and time, but life itself, furthermore, is essentially a creator of forms. Life is form, and form is the modality of life. The relationships that bind forms together in nature cannot be pure chance, and what we call "natural life" is in effect a relationship between forms, so inexorable that without it this natural life could not exist. So it is with art as well. The formal relationships within a work of art and among different works of art constitute an order for, and a metaphor of, the entire universe.

In considering form as the graph of an activity, however, we are exposed to two dangers. The first is that of stripping it bare, of reducing it to a mere contour or diagram. We must instead envisage form in all its fullness and in all its many phases; form, that is, as a *construction* of space and matter; whether it be manifested by the equilibrium of its masses, by variations from light to dark, by tone, by stroke, by spotting; whether it be architectural, sculptural, painted or engraved. The second danger is that of separating the graph from the activity and of considering the latter by itself alone. Although an earthquake exists independently of the seismograph, and barometric variations exist without any relation to the indicating needle, a work of art exists only insofar as it is form. In other words, a work of art is not the outline or the graph of art as an activity; it is art itself. It does not design art; it creates it. Art is made up, not of the artist's intentions, but of works of art. The most voluminous collection of commentaries and memoirs, written by artists whose understanding of the problems of form is fully equaled by their understanding of words,

33

could never replace the meanest work of art. In order to exist at all, a work of art must be tangible. It must renounce thought, must become dimensional, must both measure and qualify space. It is in this very turning outward that its inmost principle resides. It lies under our eyes and under our hands as a kind of extrusion upon a world that has nothing whatsoever in common with it save the pretext of the image in the so-called "arts" of imitation.

Nature as well as life creates forms. So beautifully does she impress shape and symmetry upon the very elements of which she herself is made and upon the forces with which she animates them that men have been pleased to regard her from time to time as the work of some God-artist, some unknown and guileful Hermes, the inventor and contriver. Form inhabits the shortest wavelengths, no less than those of the lowest frequency. Organic life designs spirals, orbs, meanders and stars, and if I wish to study this life, I must have recourse to form and to number. But the instant these shapes invade the space and the materials specific to art, they acquire an entirely new value and give rise to entirely new systems.

Now, that these new values and new systems should retain their alien quality is a fact to which we submit with a very poor grace. We are always tempted to read into form a meaning other than its own, to confuse the notion of form with that of image and sign. But whereas an image implies the representation of an object, and a sign signifies an object, form signifies only *itself*. And whenever a sign acquires any prominent formal value, the latter has so powerful a reaction on the value of the sign as such that it is either drained of meaning or is turned from its regular course and directed toward a totally new life. For form is surrounded by a certain aura: although it is our most strict definition of space, it also suggests to us the existence of other forms. It prolongs and diffuses itself throughout our dreams and fancies: we regard it,

as it were, as a kind of fissure through which crowds of images
aspiring to birth may be introduced into some indefinite realm —
a realm which is neither that of physical extent nor that of pure
thought. Perhaps in this way may best be explained all the deco-
rative variations that have been given to the letters of the alpha-
bet, and more specifically, the real meaning of calligraphy in the
arts of the Far East. A sign is, in other words, treated according
to certain rules: it is brushed with light or heavy strokes, with
rapidity or deliberation, with embellishments or abbreviations.
Each one of these treatments constitutes a different manner. Such
a sign cannot, then, help but welcome a symbolism that not only
fixes itself to the semantic value, but has as well the faculty of
fixing itself so fast that it becomes in turn an entirely fresh seman-
tic value. Another example — and one that is nearer home — of
the interplay of these exchanges and stratifications of form is the
decorative treatment of the Arabic alphabet (Figure 1) and the
use made of Kufi characters by the Christian art of the Occident.

Can form, then, be nothing more than a void? Is it only a
cipher wandering through space, forever in pursuit of a number
that forever flees from it? By no means. Form has a meaning —
but it is a meaning entirely its own, a personal and specific value
that must not be confused with the attributes we impose on it.
Form has a significance, and form is open to interpretation. An
architectural mass, a relationship of tones, a painter's touch, an
engraved line exist and possess value primarily in and of them-
selves. Their physiognomic quality may closely resemble that of
nature, but it must not be confused with nature. Any likening of
form to sign is a tacit admission of the conventional distinction
between form and subject matter — a distinction that may become
misleading if we forget that the fundamental content of form is a
formal content. Form is never the catch-as-catch-can garment of
subject matter. No, it is the various interpretations of subject mat-

ter that are so unstable and insecure. As old meanings are broken down and obliterated, new meanings attach themselves to form. The great network of ornament in which the successive divinities and heroes of Mesopotamia are caught fast changes its name without ever changing its shape. The very moment form appears, moreover, it can be construed in many different ways. Even in the most highly organic periods, when art, as Émile Mâle has pointed out, faithfully obeys strict and rigorous rules — such as those laid down by mathematics, music or symbolism — it may well be questioned whether the theologian who dictates the program, the artist who executes it and the devotee who subscribes to its lessons all understand and interpret form in quite the same way. For in the life of the mind, there is a region in which forms that are defined with the utmost exactitude nevertheless speak to us in very different languages. I may take as an example the Sibyl of Auxerre. There, deep within the shadows of time and of the church, it stands before us, in matter-of-fact materials around which many beautiful and gratuitous dreams have been woven. What in our day Maurice Barrès saw in these materials the artist himself saw centuries ago. But how marked the difference between the creation of the interpreter and that of the workman and, again, between that of the priest who first conceived the design and that of the other dreamers of a later day, who, as generation succeeded generation, have been mindful of the suggestions called forth by form.

Iconography may be understood in several different ways. It is either the variation of forms on the same meaning, or the variation of meanings on the same form. Either method sheds an equal light on the respective independence of these two terms. Sometimes form might be said to exert a magnetic attraction on a great variety of meanings, or rather, it might be compared to a kind of mold, into which are successively cast different materi-

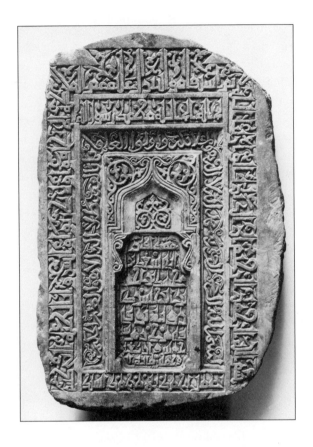

Figure 1. Tombstone of Abu Sa'd, son of Muhammad.

als that, yielding to the contours that then press upon them, acquire a wholly unexpected significance. Sometimes, again, the insistent fixity of one meaning will take complete possession of formal experiments that it did not necessarily provoke. And sometimes form, although it has become entirely void of meaning, will not only survive long after the death of its content, but will even unexpectedly and richly renew itself. By copying the coils of snakes, sympathetic magic invented the interlace. The medical origin of this sign cannot be doubted: a trace of it persists among the symbolic attributes of Aesculapius. But the sign itself becomes form and, in the world of forms, it gives rise to a whole series of shapes that subsequently bear no relation whatsoever to their origin. The interlace, for instance, lends itself to innumerable variations in the decoration of the architectural monuments of certain East Christian sects: it may weave various shapes into single indissoluble ornaments; it may submit to syntheses that artfully conceal the relationship of their component parts; or it may evoke from that genius for analysis so typical of Islam the construction and isolation of completely stylized patterns. In Ireland the interlace appears as a transitory, but endlessly renewed meditation on a chaotic universe that deep within itself clasps and conceals the debris or the seeds of humankind (Figure 2). The interlace twines round and round the old iconography, and devours it. It creates a picture of the world that has nothing in common with the world, and an art of thinking that has nothing in common with thought.

Thus, even in limiting ourselves to the consideration of a perfectly simple linear scheme, some idea of the immense activity of forms is at once made clear to us. Forms tend to manifest themselves with extraordinary vigor. This may, for example, be observed as regards language, where the verbal sign can become the mold for many different interpretations and, having attained

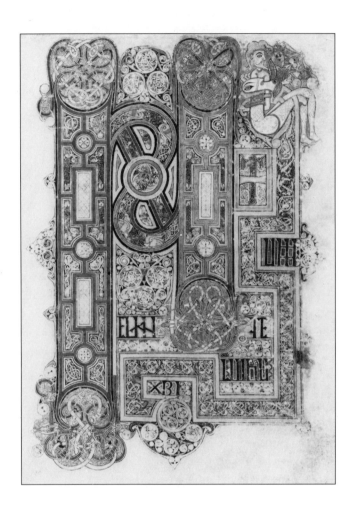

Figure 2. The Book of Kells, *The Beginning of St. Mark's Gospel.*

form, experience many remarkable adventures. I am not, in writing these lines, unmindful of the perfectly legitimate criticism raised by Michel Bréal against the theory formulated by Arsène Darmsteter in his *Life of Words*. The verbal sign, endowed as it is with both real and metaphorical independence, lavishly expresses certain aspects of the life of the mind, of the passive and active aptitudes of the human spirit. It exhibits a wonderful ingenuity in the various processes of the distortion and the ultimate extinction of words. But to say that it wastes away, that it proliferates and that it creates monstrosities is equally true. A wholly unforeseen event may provoke these processes; a shock the force of which is both extrinsic and superior to the factors of history may touch off and activate even more singular processes of destruction, deviation and invention. In passing from these complex depths of the life of language to the lofty regions where language acquires aesthetic value, we can see again the verification of the principle formulated above — a principle whose effects we shall often note during the course of this study, namely: the sign bears general significance, but having attained form, it strives to bear its own individual significance; it creates its own new meaning; it seeks its own new content, and then endows that content with fresh associations by the dislocation of familiar verbal molds. The struggle between the two extremes of the purist ideal and the deliberate manufacture of inexact and inadequate language is a notable episode in the development of this principle. The struggle between purism and verbal "impropriety" may be interpreted in two ways: either as the effort toward the greatest possible semantic energy, or as the twofold manifestation of a hidden travail from which spring forms that are untouched and uninfluenced by any of the fickle changes of meaning.

Again, plastic forms offer peculiarities that are no less remarkable. It is my conviction that we are entirely justified in our

assumption that such forms constitute an order of existence and that this order has the motion and the breath of life. Plastic forms are subjected to the principle of metamorphoses, by which they are perpetually renewed, as well as to the principle of styles, by which their relationship is, although by no means with any regularity of recurrence, first tested, then made fast and finally disrupted.

Whether constructed of masonry, carved in marble, cast in bronze, fixed beneath varnish, engraved on copper or on wood, a work of art is motionless only in appearance. It seems to be set fast – arrested, as are the moments of time gone by. But in reality it is born of change, and it leads on to other changes. (Within the same shape there are often many such changes, as in the preliminary sketches of painters who, seeking the accuracy or the exact beauty of a movement, will superimpose the drawing of several arms on the same shoulder. Rembrandt's sketches swarm across Rembrandt's paintings. The rough draft always gives vitality to the masterpiece.) A score of experiments, be they recent or forthcoming, are invariably interwoven behind the well-defined evidence of the image. This mobility of form, however, this ability to engender so great a diversity of shapes, is even more remarkable when examined in the light of certain narrower limits. The most rigorous rules, apparently intended to impoverish and to standardize formal material, are precisely those which, with an almost fantastic wealth of variations and of metamorphoses, best illuminate its superb vitality. What could be more removed from life, from its ease and its flexibility, than the geometric combinations of Islamic ornament? These combinations are produced by mathematical reasoning. They are based on cold calculation; they are reducible to patterns of the utmost aridity. But deep within them, a sort of fever seems to goad on and to multiply the shapes; some mysterious genius of complication interlocks,

41

enfolds, disorganizes and reorganizes the entire labyrinth. Their very immobility sparkles with metamorphoses. Whether they be read as voids or as solids, as vertical axes or as diagonals, each one of them both withholds the secret and exposes the reality of an immense number of possibilities. An analogous phenomenon occurs in Romanesque sculpture. Here, abstract form is both stem and support for a strange, chimerical image of animal and human life; here, monsters that are shackled permanently to an architectural and ornamental definition are yet endlessly reborn in so many different ways that their captivity mocks both us and itself (Figure 3). Form becomes a *rinceau*, a double-headed eagle, a mermaid, a duel of warriors. It duplicates, coils back on and devours its own shape. Without once trespassing its limits or falsifying its principles, this protean monster rouses up and unrolls its demented existence – an existence that is merely the turmoil and the undulation of a single, simple form.

The objection will perhaps be raised that no matter how much abstract form and fantastic form are restrained by fundamental necessities and, as it were, imprisoned within them, they are at least free as regards the models of nature. It might also be maintained that a work of art which respects the models of nature does not need to obey the formal principles I have just described. This is by no means the case, since the models of nature may themselves be regarded as the stem and support of metamorphoses. The body of man and the body of woman can remain virtually constant, but the ciphers capable of being written with the bodies of men and women are inexhaustibly various, and this variety works on, activates and inspires all works of art, from the most elaborate to the most serenely simple. We do not, it is true, turn for examples of this to those pages of the *Mangwa* which Hokusai covered with his sketches of acrobats, but rather to the compositions of Raphael. When Daphne, in the fable, is transformed

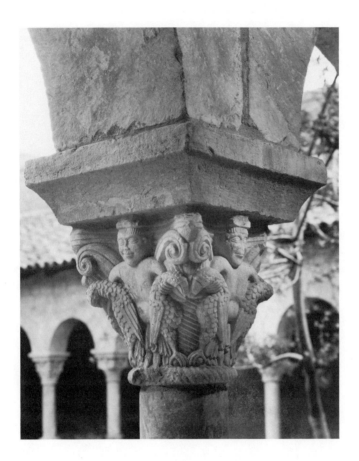

Figure 3. Capital from Abbey of St. Michael and St. Germain, Cuxa.

into a laurel, she must pass from one realm into another. A more subtle and no less extraordinary metamorphosis also involving the body of a beautiful young woman, is that which leads us from the *Orléans Madonna* to the *Madonna della Sedia*, which, with its even, pure volute, resembles nothing so much as some exquisite sea-shell. It is, however, in those compositions by Raphael that are laden with whole garlands of human bodies (Figure 4) that we can best comprehend the genius for harmonic variations that combines over and over again those shapes wherein the life of forms has absolutely no aim other than itself and its own renewal. The mathematicians in the *School of Athens*, the soldiers in the *Massacre of the Innocents*, the fishermen in the *Miracle of the Fishes*, Imperia seated at the feet of Apollo or kneeling before Christ — all these are the successive interlaces of a formal thought composed of and supported by the human body, and by means of which are contrived symmetries, contrappostos and alternating rhythms. Here, the metamorphosis of shapes does not alter the factors of life, but it does compose a new life — one that is no less complex than that of the monsters of Asiatic mythology or of Romanesque sculpture. But whereas these latter are fettered hand and foot by abstract armatures and by monotonous calculations, the ornament of human form remains identical and intact in its harmony and draws ceaseless new compulsions from that very harmony. Form may, it is true, become formula and canon; in other words, it may be abruptly frozen into a normative type. But form is primarily a mobile life in a changing world. Its metamorphoses endlessly begin anew, and it is by the principle of *style* that they are above all coordinated and stabilized.

This term has two very different, indeed two opposite meanings. Style is an absolute. *A* style is a variable. The word "style" in its generic sense indicates a special and superior quality in a work of art: the quality, the peculiarly eternal value, that allows it to

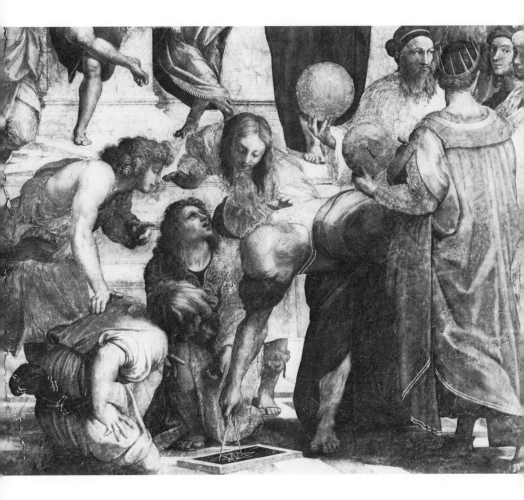

Figure 4. Raphael: Detail from School of Athens.

escape the bondage of time. Conceived as an absolute, style is not only a model, but also something whose validity is changeless. It is like a great summit that, rising between two slopes, sharply defines the expanse of skyline. In utilizing style as an absolute, we give expression to a very fundamental need: that of beholding ourselves in our widest possible intelligibility, in our most stable, our most universal aspect, beyond the fluctuations of history, beyond local and specific limitations. A style, on the other hand, is a development, a coherent grouping of forms united by a reciprocal fitness, whose essential harmony is nevertheless in many ways testing itself, building itself and annihilating itself. Pauses, tensions, relaxations occur in the best defined of styles. This fact was established long ago by the study of the monuments of architecture. The founders of medieval archaeology in France, especially Arcisse de Caumont, taught us that Gothic art, for example, could not be regarded merely as a heterogeneous collection of monuments. By means of a strict analysis of forms, it was defined as a style, that is, as a closely related sequence and succession. A comparable analysis shows that all the arts may be comprehended by this same token of a style — even to the very life of mankind, insofar as its individual life and its historical life are both forms.

What, then, constitutes a style? First, its formal elements, which have a certain index value and which make up its repertory, its vocabulary and, occasionally, the very instrument with which it wields its power; second, although less obviously, its system of relationships, its syntax. The affirmation of a style is found in its measures. In such wise did the Greeks understand a style when they defined it by the relative proportions of its parts. Rather than the mere substitution of volutes for a molding on the capital, it is a measure that distinguishes the Ionic from the Doric order, and it is clear that the column of the temple of Nemea is an aberration, since it has Ionic measures, although its elements

are Doric. The history of the Doric order, that is, its stylistic development, consists solely of variation on and studies of measure. But there are other arts whose component elements also possess a truly fundamental value. One of these is Gothic art. It might well be said that the rib vault (Figure 5) contains Gothic art in its entirety, composes it and controls the derivation of all its parts, although we should not forget that in certain monuments the rib vault does appear without engendering a style, that is, a series of planned harmonies. The earliest Lombard rib vaults, for example, had no issue in Italy. The style of the rib vault developed in other countries, and in other countries its possibilities grew and became coherent.

This activity on the part of a style in the process of self-definition, that is, defining itself and then escaping from its own definition, is generally known as an "evolution," this term being here understood in its broadest and most general sense. Biological science checked and modulated the concept of evolution with painstaking care; archaeology, on the other hand, took it simply as a convenient frame, a method of classification. I have elsewhere pointed out the dangers of "evolution": its deceptive orderliness, its single-minded directness, its use, in those problematic cases in which there is discord between the future and the past, of the expedient of "transitions," its inability to make room for the revolutionary energy of inventors. Any interpretation of the movements of styles must take into account two essential facts. First, several styles may exist simultaneously within neighboring districts and even within the same district; second, styles develop differently in accordance with whatever technical domain they may occupy. With these reservations established, the life of a style may be considered either as a dialectic or as an experimental process.

Nothing is more tempting — and in certain cases nothing is better warranted — than to show how forms comply with an inter-

nal, organizing logic. In the same way that sand spread out on the diaphragm of a violin would fall into different symmetrical figures in response to the strokes of a bow, so does a secret principle, stronger and more rigorous than any possible creative conceit, summon together forms that multiply by mitosis, by change of key or by affinity. This is certainly the case in the mysterious domain of ornament, as well as in any art that borrows and subjects the pattern of the image to ornament. For, the essence of ornament is that it may be reduced to the purest forms of comprehensibility and that geometrical reasoning is infallibly applicable to the analysis of the relationship between its parts. This was the method pursued by Jurgis Baltrusaitis in his brilliant studies of the dialectic of ornament in Romanesque sculpture. In studies of this sort, it is by no means improper to equate style and stylistic analysis, in the sense of "reconstructing" a logical process that already exists, with a force and power more than adequately evident, within the styles themselves. It is of course understood that the character of this process varies in quality and uniformity according to time and place. But it is still perfectly true that an ornamental style takes shape and exists as such only by virtue of the development of an internal logic, of a dialectic worth nothing except in relation to itself. Variations in ornament are not occasioned by the incrustation of alien elements or by a merely accidental choice, but by the play of hidden rules. This dialectic both accepts and demands new contributions, according to its own needs. Whatever has been contributed has already been demanded. The dialectic may, indeed, invent such contributions. A doctrine that still colors many of our studies in the history of art, that is, the doctrine that "influences" may be interpreted in one heterogeneous mass and considered as resulting from impact and conflict, must therefore be qualified and tempered.

This interpretation of the life of styles is one that is admira-

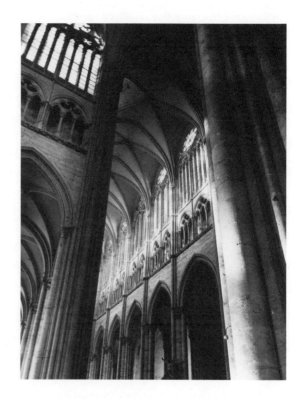

Figure 5. Gothic Rib-Vault, Amiens.

bly adapted to the subject of ornamental art. But is it adequate
in all other cases? To architecture, and especially to Gothic archi-
tecture (when considered as the development of a theorem), it
has been applied in speculations that were both absolute and, as
regards ordinary historical activity, practical. Indeed, it is nowhere
possible to behold more clearly than in Gothic architecture how,
from a given form, there are derived to the very last detail the
happy issues that affect the structure, the organization of masses,
the relation of voids to solids, the treatment of light and even the
decoration itself. No graph, apparent or real, could be more
plainly indicated. It would be a mistake, however, not to recog-
nize in this graph the action of an *experiment* at each of its crucial
points. By experiment I mean an investigation that is supported
by prior knowledge, based on a hypothesis, conducted with intel-
ligent reason and carried out in the realm of technique. In this
sense it may well be said that Gothic architecture is guesswork
and reasoning, empirical research and inner logic all at once. The
proof of its experimental character is the fact that, in spite of the
rigorousness of its methods, some of its experiments remained
almost wholly without results; in other words, much was wasted
and much was barren. How little do we know of the innumera-
ble mistakes that lurk in the shadow of success! Examples of such
mistakes could perhaps be discovered in the history of the flying
buttress, which was originally a concealed wall, with a cut-out
passage, and later became an arch, awaiting its transformation into
a rigid prop. Furthermore, the notion of logic in architecture is
applicable to several different functions, which sometimes coin-
cide and sometimes do not. The logic of the eye, with its need
for balance and symmetry, is not necessarily in agreement with
the logic of structure, which in turn is not the logic of pure intel-
lect. The divergence of these three kinds of logic is remarkable
in certain states of the life of styles, among others in flamboyant

art. But it is, nevertheless, admissible to suppose that the exper-
iments of Gothic art, bound powerfully one to the other, and in
their royal progress discarding all solutions that were either haz-
ardous or unpromising, constitute by their very sequence and con-
catenation a kind of logic — an irresistible logic that eventually
expresses itself in stone with a classic decisiveness.

If we turn from ornament and architecture to the other arts,
and especially to painting, we see that the life of forms is mani-
fested in these arts by a larger number of experiments, and that
it is subjected to more frequent and more unexpected variations.
For the measures are here more delicate and sensitive, and the
material itself invites a degree of research and experiment that
must be constantly proportionate to its manageability. Further,
the notion of style — a notion that is equally applicable to every-
thing, including the art of living — is qualified by materials and
techniques: it does not behave uniformly or synchronously in all
realms. Then, too, each historical style exists under the aegis of
one technique that overrides other techniques and that gives to
the style its tonality. This principle, which may be called the
law of technical primacy, was formulated by Louis Bréhier with
respect to those barbarian arts that were dominated by ornamental
abstraction rather than by anthropomorphic design and by archi-
tecture. But, on the other hand, it is architecture that receives
the tonic of the Romanesque and the Gothic styles. And we know
how painting, at the end of the Middle Ages, tends to encroach
on, to redirect and finally to triumph over all the other arts. And
yet, within one given style that is homogeneous and faithful to
its technical primacy, the various arts live and move with perfect
freedom. Each subordinate art seeks to come into agreement with
the dominant art. This it attains through experiments, not the
least interesting examples of which are the adaptation of the
human form to ornamental designs or the variations in monumen-

tal painting due to the influence of stained glass windows. The reason for this is that each one of the arts is attempting to live for itself and to liberate itself, until the day comes when it may take its own turn as the dominant art.

Although the uses to which this law of technical primacy may be put are virtually inexhaustible, it is, perhaps, but one aspect of a more general law. Each style passes through several ages and several phases of being. This does not mean that the ages of style and the ages of mankind are the same thing. The life of forms is not the result of chance. Nor is it a great cyclorama neatly fitted into the theater of history and called into being by historical necessities. No. Forms obey their own rules — rules that are inherent in the forms themselves, or better, in the regions of the mind where they are located and centered — and there is no reason why we should not undertake an investigation of how these great ensembles, united by close reasoning and by coherent experiment, behave throughout the phases that we call their life. The successive states through which they pass are more or less lengthy, more or less intense, according to the style itself: the experimental age, the classic age, the age of refinement, the baroque age. These distinctions are perhaps not wholly new, but it must be borne in mind that — as Waldemar Déonna has pointed out in a penetrating analysis of certain epochs in the history of art — these ages or states present the same formal characteristics at every epoch and in every environment. This is so unmistakably the case that we need not be surprised in noting close similarities between Greek archaism and Gothic archaism, between Greek art of the fifth century B.C. and the sculptures of the first half of the thirteenth century A.D., between the flamboyant, or baroque state of Gothic, and eighteenth-century rococo art. The history of forms cannot be indicated by a single ascending line. One style comes to an end; another comes to life. It is only natural that

mankind should revaluate these styles over and over again, and it is in the application to this task that I apprehend the constancy and the identity of the human spirit.

The experimental state is the one in which style is seeking to define itself. This is generally called archaism, in either the pejorative or the laudatory sense, according to whether we see in it a crude inarticulateness or an auspicious promise, dependent, obviously, on the historical moment that we ourselves occupy. If we follow the history of Romanesque sculpture during the eleventh century, we become aware of the apparently unsystematic and "crude" experiments whereby form seeks not only to exploit ornamental variations, but also to incorporate man himself into them, thus adapting him to certain architectural functions, even though in the eleventh century man, as man, had not yet become an object of study, and far less a universal measure. The plastic treatment of the human body was still concerned with the integrity of the masses and their density as blocks or as walls. The modeling, a mere gentle undulation, did not penetrate below the surface; the thin, shallow folds possessed no more than a calligraphic value. And such is the course followed by every archaism. Greek art begins with that same massive unity, that same plenitude and density. It dreams of monsters that it has not yet turned into men; it is indifferent to the musical quality of those human proportions whose various canons dominate its classic age; it seeks for variations only in a tectonic order that is conceived primarily in terms of bulk. In Romanesque archaism, as in Greek, experimentation proceeds with disconcerting speed. The sixth century B.C., like the eleventh A.D., suffices for the elaboration of a style; the first half of the fifth B.C. and the first third of the twelfth A.D. witness its flowerings. Gothic archaism is perhaps even more rapid. It multiplies structural experiments, creates types that would normally be considered as stopping points and continues

to renew them until, with Chartres, its future has been, as it were, ordained. The sculpture of the same period presents a remarkable example of the constancy of these laws: it has no meaning if it be regarded as the ultimate expression of Romanesque art or as the "transition" from Romanesque to Gothic. For an art of movement, this sculpture substitutes an art of frontality and immobility; for a grandiose arrangement of the tympani, the reiteration of the Christ enthroned within the tetramorph. Its manner of imitating Languedocian types shows it as retrograding from these latter, older models; it has entirely forgotten the rules of style that implement the Romanesque classicism, and whenever it seems to draw inspiration from that source, it does so by contradiction: form and iconography no longer agree. This sculpture of the second half of the twelfth century, contemporary with Romanesque baroque, undertakes its experiments in another direction, and for other ends. It is starting afresh.

It would be idle to attempt to enrich the long series of definitions that have been given for classicism. Simply by regarding it as a state, or as a moment, I have already qualified it. But it is never beside the point to remember that classicism consists of the greatest propriety of the parts one to the other. It is stability, security, following on experimental unrest. It confers, so to speak, a solidity on the unstable aspects of experimentation (because of which it is also, in a way, a renunciation). Thus it is that the endless life of styles coincides with style as a universal value, that is, as an order whose value never ceases, and which, far beyond the graph of time, establishes what I have called the expanse of skyline. But classicism is not the result of a conformist attitude. On the contrary, it has been created out of one final, ultimate experiment, the audacity and vitality of which it has never lost. How good it would be could we rejuvenate this venerable word — a word that has today lost all meaning through so much careless

and indeed illegitimate usage! Classicism: a brief, perfectly bal-
anced instant of complete possession of forms; not a slow and
monotonous application of "rules," but a pure, quick delight, like
the ἀκμή of the Greeks, so delicate that the pointer of the scale
scarcely trembles. I look at this scale not to see whether the
pointer will presently dip down again, or even come to a moment
of absolute rest. I look at it instead to see, within the miracle of
that hesitant immobility, the slight, inappreciable tremor that
indicates life. It is for this reason that the classic state differs rad-
ically from the academic state, which is merely a lifeless reflec-
tion, a kind of inert image. It is for this reason that the analogies
or identities occasionally revealed by the various types of classi-
cism in the treatment of forms are not necessarily the result of
an influence or imitation. The wonderful statues of the Visita-
tion, full, calm, monumental, on the north portal of Chartres, are
much more "classic" than the figures at Rheims whose draperies
suggest a direct imitation of Roman models. Classicism is by no
means the unique privilege of ancient art, which itself passed
through different states and ceased being classic art when it
became baroque art. If the sculptors of the first half of the thir-
teenth century had constantly drawn inspiration from that so-
called Roman classicism of which France retained so many traces,
they would have ceased being classic. A remarkable proof may be
seen in a monument that deserves a careful analysis: the Belle
Croix of Sens (Figure 6). The Virgin, as she stands beside her cru-
cified son in all her simplicity and in all the absorption and chas-
tity of her grief, still bears the traits of that first experimental age
of the Gothic genius that recalls the dawn of the fifth century
B.C. But the figure of Saint John on the other side of the cross is,
in the treatment of the draperies, plainly an imitation of some
mediocre Gallo-Roman full-round work, and particularly in the
lower part of the body it is entirely out of key with the purity of

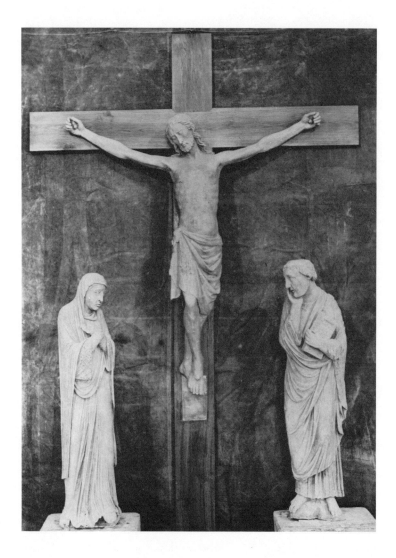

Figure 6. La Belle Croix, *Sens.*

the group as a whole. The classic state of a style is not attained from without. The dogma of slavish imitation of the ancients can serve the objectives of any romanticism.

This is not the place to show how forms pass from the classic state to those experiments in refinement that, as regards architecture at least, enhance the elegance of structural solutions to what may seem a very bold paradox, and that reach that state of dry purity and of calculated interdependence of the parts so singularly well-expressed in the style known as *art rayonnant*. Nor to show how, in the meanwhile, the image of man discards little by little its monumental character, loses contact with architecture and becomes elongated and enriched with new axial torsions and with more subtle modeling. The poetry of bare flesh as an artistic subject induces every sculptor to become, after a fashion, a painter, and arouses in him a taste for the warmth of reality. Flesh becomes flesh; it loses the quality, the look of stone. Ephebism in the representation of man is not the sign of the youth of an art; it is, on the contrary, perhaps the first gracious annunciation of decline. The svelte, alert figures of the Resurrection on the main portal of Rampillon (Figure 7), the statue of Adam from St. Denis (despite its restorations) and certain fragments from Notre Dame — all these shed over French art at the end of the thirteenth century and during the entire fourteenth century a truly Praxitelean light. Such comparisons are no longer, we feel, merely matters of taste on our part; they seem to be justified by an inner life that is incessantly active, incessantly effective in various periods and environments of human civilization. It might be perhaps permissible to explain in this way, and not simply by means of analogies of process, the characteristics held in common by quite different things. One might cite, for instance, the figures of women that were painted on the sides of Attic funerary lekythoi in the fourth century B.C., and those whose sen-

sitive, flexible likenesses the Japanese masters designed with their little brushes for the wood engravers at the end of the eighteenth century.

The baroque state likewise reveals identical traits existing as constants within the most diverse environments and periods of time. Baroque was not reserved exclusively for the Europe of the last three centuries any more than classicism was the unique privilege of Mediterranean culture. In the life of forms, baroque is indeed but a moment, but it is certainly the freest and the most emancipated one. Baroque forms have either abandoned or denatured that principle of intimate propriety, an essential aspect of which is a careful respect for the limits of the frame, especially in architecture. They live with passionate intensity a life that is entirely their own; they proliferate like some vegetable monstrosity. They break apart even as they grow; they tend to invade space in every direction, to perforate it, to become as one with all its possibilities. This mastery of space is pure delight to them. They are obsessed with the object of representation; they are urged toward it by a kind of maniacal "similism." But the experiments into which they are swept by some hidden force constantly overshoot the mark. These traits are remarkable, nay, strikingly noticeable, in baroque ornamental art. Never has abstract form a more obvious — although not necessarily a more powerful — mimic value. And the confusion between form and sign never becomes more complete. Form no longer signifies itself alone; it signifies as well a wholly deliberate content, and form is tortured to fit a "meaning." It is here that the primacy of painting may be seen coming into play, or, better, it is here that all the arts pool their various resources, cross the frontiers that separate them and freely borrow visual effects one from the other. At the same time, by a curious inversion that is governed by a nostalgia arising from the very forms themselves, an interest in the past is

Figure 7. Detail of the Resurrection from the Main Portal at Rampillon.

awakened, and baroque art seeks models and examples and con-
firmations from the most remote regions of antiquity. But what
baroque wants from history is the past life of baroque itself.
Exactly as Euripides and Seneca, and not Aeschylus, inspired the
seventeenth-century French dramatists, so did the baroque of
nineteenth-century romanticism particularly admire in medieval
art the flamboyant style: that baroque form of Gothic. I do not
mean that there are exact parallels between baroque art and
romanticism at every point, and if in France these two "states"
of form appear separate and distinct, it is not simply because one
followed the other, but because a historical phenomenon of rup-
ture – a brief and violent interval of *artificial* classicism – divided
them. French painters had to cross what I may call the gulf of
David's art before they could rejoin the art of Titian, Tintoretto,
Caravaggio, Rubens and later, under the Second Empire, of the
great eighteenth-century masters.

We must never think of forms, in their different states, as sim-
ply suspended in some remote, abstract zone, above the earth and
above man. They mingle with life, whence they come; they trans-
late into space certain movements of the mind. But a definite
style is not merely a state in the life of forms, nor is it that life
itself: it is a homogeneous, coherent, formal environment, in the
midst of which man acts and breathes. It is, too, an environment
that may move from place to place *en bloc*. We find Gothic art
imported in such wise into northern Spain, into England, into
Germany, where it lived on with varying degrees of energy and
with a rhythm sufficiently rapid to permit an occasional incor-
poration of older forms that, although they had become localized,
were never vitally essential to the environment. Occasionally,
again, this rhythm may precipitate movements sooner than might
be expected. Whether stable or nomadic, all formal environments
give birth to their own various types of social structure: styles of

life, vocabularies, states of awareness. Expressed in a more general way, the life of forms gives definition to what may be termed "psychological landscapes," without which the essential genius of the environments would be opaque and elusive for all those who share in them. Greece, for instance, exists as a geographical basis for certain ideas about man, but the landscape of Doric art, or rather, Doric art as a landscape, created a Greece without which the real Greece is merely a great, luminous desert. Again, the landscape of Gothic art, or rather, Gothic art as a landscape, created a France and a French humanity that no one could foresee: outlines of the horizon, silhouettes of cities — a poetry, in short, that arose from Gothic art, and not from geology or from Capetian institutions. But is not the essential attribute of any environment that of producing its own myths, of shaping the past according to its own needs? Formal environment creates historical myths that are fashioned not only by the state of existing knowledge and by existing spiritual needs, but also by the exigencies of form. Take, for example, the long succession of fables that, appearing, disappearing and reappearing, have come down to us from the remotest Mediterranean antiquity. According to whether these fables are embodied in Romanesque art or Gothic art, in humanist art or baroque art, in David's art or romantic art, they change shape, they fit themselves to different frames and different curves, and, in the minds of those who witness metamorphoses such as these, they evoke wholly different, if not indeed wholly opposite, images. These fables occur in the life of forms, not as an irreducible factor nor as a foreign body, but as a true substance, plastic and docile.

It may seem that I have laid down a far too unwieldy determinism in underlining with such insistence the various principles that rule the life of forms and that so react upon nature, man and history as to constitute an entire universe and humanity. It may

seem that I am anxious to isolate works of art from human life, and condemn them to a blind automatism and to an exactly predictable sequence. This is by no means so. The state of a style or, if one prefers, a state in the life of forms, is simultaneously the guarantor and the promoter of *diversity*. Man's spirit is truly free in the impregnability of a high intellectual self-expression. The power of formal order alone authorizes the ease and spontaneity of creation. A large number of experiments and variations is likely to occur whenever the artist's expression is at all confined, whereas unlimited freedom inevitably leads to imitation. In case these principles should be disputed, two observations may be made that will shed light on the qualities of activity and of apparent uniqueness that coexist within the closely knit phenomena of forms.

First, forms are not their own pattern, their own mere naked representation. Their life develops in a space that is not the abstract frame of geometry; under the tools and at the hands of men it assumes substance in a given material. It is there and not elsewhere that forms exist, that is, in a highly concrete, but highly diversified world. An identical form keeps its dimensions, but changes its quality according to the material, the tool and the hand. A text does not change because of the different papers on which it chances to be printed; the paper is but the support for the text. In a drawing, however, the paper is an element of life; it is the very heart of the design. A form without support is not form, and the support itself is form. It is essential, therefore, to bear in mind how immense is the variety of techniques in the genealogy of a work of art, and to show that the principle of all technique is not inertia, but activity.

And second, man himself, who is no less diversified, must be taken into consideration. The source of man's diversity does not lie in the accord or disaccord of race, environment or time, but

in quite another region of life, which seems to comprise affinities and accords far more subtle than those that preside over the general historical groupings of mankind. There exists a kind of spiritual ethnography that cuts across the best-defined "races." It is composed of families of the mind — families whose unity is effected by secret ties and who are faithfully in communication with one another, beyond all restrictions of time or place. Perhaps each style, each state of a style, even each technique seeks out by preference a certain state of man's nature, a certain spiritual family. In any case, it is the relationship between these three values that clarifies a work of art not only as something that is unique, but also as something that is a living word in a universal language.

Forms in the Realm of Space

A work of art is situated in space. But it will not do to say it simply exists in space: a work of art treats space according to its own needs, defines space and even creates such space as may be necessary to it. The space of life is a known quantity to which life readily submits; the space of art is a plastic and changing material. We may find it difficult to admit this, so completely are we influenced by the rules of Albertian perspective. But many other perspectives exist as well, and rational perspective itself, which constructs the space of art on the model of the space of life, has, as will presently be seen, a far greater propensity than we think to strange fictions and paradoxes. An effort is needed to admit that anything that may elude the laws of space is still a legitimate treatment of space. Perspective, moreover, pertains only to the plane representation of a three-dimensional object, and this problem is but one among others with which we are confronted. Let us note at once, however, that it is impossible to consider every one of these problems *in abstracto* or to reduce them to a certain number of general solutions that would condition each particular application. Form is not indiscriminately architecture, sculpture or painting. Whatever exchanges may be made between techniques – however decisive the authority of one over the oth-

ers — form is qualified above all else by the specific realms in which it develops, and not simply by an act of reason on our part, a wish to see form develop regardless of circumstances.

There is, however, one art that seems to be capable of immediate translation into various different techniques: namely, ornamental art, perhaps the first alphabet of our human thought to come into close contact with space. It is, too, an art that takes on a highly individual life — although one that is oftentimes drastically modified by its expression in stone, wood, bronze or brushstroke. It commands, moreover, a very extensive area of speculation; it is a kind of observatory from which it is possible to discern certain elementary, generalized aspects of the life of forms within their own space. Even before it becomes formal rhythm and combination, the simplest ornamental theme, such as a curve or *rinceau* whose flexions betoken all manner of future symmetries, alternating movements, divisions and returns, has already given accent to the void in which it occurs and has conferred on it a new and original existence. Even if reduced merely to a slender and sinuous line, it is already a frontier, a highway. Ornament shapes, straightens and stabilizes the bare and arid field on which it is inscribed. Not only does it exist in and of itself, but it also shapes its own environment — to which it imparts a form. If we will follow the metamorphoses of this form, if we will study not merely its axes and its armature, but everything else that it may include within its own particular framework, we will then see before us an entire universe that is partitioned off into an infinite variety of blocks of space. The background will sometimes remain generously visible, and the ornament will be disposed in straight rows or in quincunxes; sometimes, however, the ornament will multiply to prolixity and wholly devour the background against which it is placed.

This respect for, or cancellation of, the void creates two orders

of shapes. For the first, it would seem that space liberally allowed around forms keeps them intact and guarantees their permanence. For the second, forms tend to wed their respective curves, to meet, to fuse or, at least, from the logical regularity of correspondences and contacts, to pass into an undulating continuity where the relationship of parts ceases to be evident, where both beginning and end are carefully hidden. In other words, what I may call "the system of the series" — a system composed of discontinuous elements sharply outlined, strongly rhythmical and defining a stable and symmetrical space that protects them against unforeseen accidents of metamorphosis — eventually becomes "the system of the labyrinth," which, by means of mobile syntheses, stretches itself out in a realm of glittering movement and color. As the eye moves across the labyrinth in confusion, misled by a linear caprice that is perpetually sliding away to a secret objective of its own, a new dimension suddenly emerges, which is a dimension neither of motion nor of depth, but which still gives us the illusion of being so. In the Celtic gospels, the ornament, which is constantly overlaying itself and melting into itself, even though it is fixed fast within compartments of letters and panels, appears to be shifting among different planes at different speeds.

It must be obvious that, in the study of ornament, these essential factors are not less important than are pure morphology and genealogy. My statement of the situation might appear entirely too abstract and systematic, were it not henceforth evident that this strange realm of ornament — the chosen home of metamorphoses — has given birth to an entire flora and fauna of hybrids that are subject to the laws of a world distinctly not our own. The qualities of permanence and energy implicit in this realm are extraordinary; although it welcomes both men and animals into its system, it yields nothing to them — it incorporates them. New images are constantly being composed on the same figures.

Engendered by the motions of an imaginary space, these figures would be so absurd in the ordinary regions of life that they would not be permitted to exist. But the more stringently the fauna of the formal labyrinth are held in captivity, so much the more zeal do they show in increasing and multiplying. These hybrids are found not only in the abstract and boldly defined frameworks of the art of Asia and of Romanesque art; they recur too in the great Mediterranean cultures, in Greece and Rome, where they appear as deposits from older civilizations. I need mention here but one example. In the grotesque ornament that was restored to fashion by the men of the Renaissance, it is evident that the charming exotic plants shaped like human beings have undergone, by being transplanted into a very large space and as it were brought back into the open air, a formal degeneration (Figure 8). They have lost their powerful, paradoxical capacity for *life*. Upon the light walls of the loggias, their elegance seems dry and fragile. No longer are these ornaments untamed, no longer endlessly distorted by metamorphoses, no longer capable of tirelessly spawning themselves over and over again. They are now merely museum pieces, torn from their natal surroundings, placed well out in the open on an empty background, harmonious and dead. Be it background, visible or concealed; support, which remains obvious and stable among the signs or which mingles in their exchanges; plan, which preserves unity and fixity or which undulates beneath the figures and blends with their movements — it is always the question of a space constructed or destroyed by form, animated by it, molded by it.

Thus, as I have already remarked, any speculation regarding ornament is a speculation on the great power of the abstract and on the infinite resources of the imaginary. It may seem altogether too obvious to say that the space occupied by ornament, with its long shoreline and the monstrous inhabitants of its many archi-

Figure 8. Architectural detail from Italy, sixteenth-century.

pelagoes, is not the space of life. No. On the contrary, ornamental space is clearly an elaboration on variable factors. Now, such may seem not to be the case as regards the forms of architecture in that they are subjected in the strictest, most passive way to spatial data that cannot change. This must be so, for, in essence and by destination, the art of architecture exerts itself in a *true* space, one in which we walk and which the activity of our bodies occupies. But only consider the manner in which an architect works, and how perfectly his forms agree with one another to utilize this space and perhaps to shape it anew. The three dimensions are not simply the *locus* of architecture; they are also, like weight and equilibrium, its very material. The relationship that unites them in a building is never casual, nor is it predetermined. The order of proportions comes into play in their treatment, confers originality on the form and models the space according to calculated proprieties. A perusal of ground plan and of elevation gives but a very imperfect notion of these relationships. A building is not a collection of surfaces, but an assemblage of parts, in which length, width and depth agree with one another in a certain fashion, and constitute an entirely new solid that comprises an internal volume and an external mass. A ground plan can, to be sure, tell us a great deal. It can familiarize us with the nature of the general program and permit a skilled eye to comprehend the chief structural solutions. An exact memory, well furnished with examples, may theoretically reconstruct a building from its projection upon the ground, and knowledge of the various schools of production will allow the expert to foresee for each category of plans all the possible consequences in the third dimension, as well as the typical solution for any given plan. But this kind of reduction or, perhaps, abbreviation of the processes of work, by no means embraces the whole of architecture. Indeed, it despoils architecture of its fundamental privilege: namely, the

mastery of a complete space, not only as a mass, but as a mold imposing a new value on the three dimensions. The notions of plan, of structure and of mass are indissolubly united, and it is a dangerous thing to attempt to disjoin them. Such certainly is not my purpose, but in laying stress on mass, I wish to make it immediately understood that it is never possible fully to comprehend architectural form in the small and abbreviated space of a working drawing.

Masses are defined first of all by proportion. If we take, for instance, the naves of the Middle Ages, we see that they are more or less lofty only in relation to their width and length. Although it is obviously important to know what the actual dimensions are, these dimensions are in truth neither passive nor accidental; nor are they matters of mere taste. The relation of number to shape gives us a glimpse of a certain science of space, which, founded perhaps on geometry, is still not pure geometry. In the work done by Viollet-le-Duc on the triangulation of St. Sernin (Figure 9), it is not easy to determine to what extent a certain susceptibility to the mysticism of numbers intervenes among the positive factual data. It is, however, undeniable that architectural masses are rigorously determined by the relationship of the parts to each other and of the parts to the whole. A building, moreover, is rarely a single mass. Rather, it is a combination of secondary masses and principal masses, and, in the art of the Middle Ages, this treatment of space attains an extraordinary degree of power, variety and even virtuosity. The composition of the apses of Romanesque Auvergne, where the volumes build up gradually, from the apsidal chapels to the lantern spire, through the roofs of the chapels, the deambulatory, the choir and the rectangular mass on which the belfry rests is a striking and familiar instance of this virtuosity. A similar process occurs in the facades of the Middle Ages, from the western apse of the great Carolingian abbeys to the

71

"harmonic" type of the Norman churches, with the intermediary stage of nartheces so highly developed that they were almost conceived as large churches in and of themselves. Rather than a wall or a simple elevation, the facade appears to be a combination of the most fully organized and voluminous masses. Finally, in the Gothic architecture of the second half of the twelfth century, the relationship of the nave to single or double aisles, of the nave to elongated or truncated transepts, the pitch of the schematic pyramid within which these masses lie and the relative continuity of the profiles — all present problems that cannot be solved by plane geometry or even, perhaps, by the interplay of proportions.

For, however necessary proportions may be to the definition of mass, they are by no means the whole story. It is possible for a mass to admit, as the case may be, few or many episodic details, apertures and visual effects. Even when reduced to the most sober mural economy, a mass still acquires great stability, still bears heavily on its base, still looks like a compact solid. Light takes possession of it uniformly and instantaneously. On the other hand, a multiplicity of lights will compromise and weaken a wall; the complexity of purely ornamental forms will threaten its equilibrium and make it seem unsteady and flimsy. Light cannot rest upon it without being broken apart; and, when subjected to such incessant alternations, the architecture wavers, fluctuates and loses all meaning. The space that presses evenly on a continuous mass is as immobile as that mass itself. But the space that penetrates the *voids* of the mass and is invaded by the proliferation of its reliefs, is mobile. Whether examples be taken from flamboyant or baroque art, this architecture of movement assumes the qualities of wind, of flame and of light; it moves within a fluid space. In Carolingian or primitive Romanesque art, the architecture of stable masses defines a massive space.

Until now, my remarks have pertained primarily to mass in

Figure 9. East view of the apse and transept of St. Sernin.

general, but it must not be forgotten that mass offers the double and simultaneous aspect of internal mass and external mass, and that the relation of one to the other is a matter of peculiar interest to the study of form in space. Each of these two aspects may, of course, be a function of the other, and cases exist in which the composition of the exterior immediately apprises us of the interior arrangement. But this rule is not invariable: it is well known, for example, how Cistercian architecture strove to disguise the complexity of the interior behind the unity of the external mural masses. The cellular partitioning of the buildings of modern America has slight influence on their external configuration. In these buildings, mass is treated as a full solid, and the architects seek for what they call the "mass envelope," exactly as the sculptor proceeds from the blocking-out to the gradual modeling of the volumes. But the profound originality of architecture as such resides perhaps in the internal mass. In lending definite form to that absolutely empty space, architecture truly creates its own universe. Exterior volumes and their profiles unquestionably interpose a new and entirely human element upon the horizon of natural forms, to which their conformity or harmony, when most carefully calculated, always adds something unexpected. But, if one gives the matter thought, it will be observed that the greatest marvel of all is the way in which architecture has conceived and created an inversion of space. Human movement and action are exterior to everything; man is always on the outside, and in order to penetrate beyond surfaces, he must break them open. The unique privilege of architecture among all the arts, be it concerned with dwellings, churches or ships, is not that of surrounding and, as it were, guaranteeing a convenient void, but of constructing an interior world that measures space and light according to the laws of a geometrical, mechanical and optical theory that is necessarily

implicit in the natural order, but to which nature itself contributes nothing.

Relying on the height of the bases and the dimensions of the portals, Viollet-le-Duc makes it clear that even the largest cathedrals are always at human scale. But the relation of that scale to such enormous dimensions impresses us immediately both with the sense of our own measure — the measure of nature itself — and with the sense of a dizzy immensity that exceeds nature at every point. Nothing could have determined the astonishing height of the naves of those cathedrals save the activity of the life of forms: the insistent theorem of an articulated structure, the need to create a new space. Light is treated not so much as an inert factor as a living element, fully capable of entering into and of assisting the cycle of metamorphoses. Light not only illuminates the internal mass, but collaborates with the architecture to give it its needed form. Light itself is form, since its rays, streaming forth at predetermined points, are compressed, attenuated or stretched in order to pick out the variously unified and accented members of the building, for the purpose either of tranquilizing it or of giving it vivacity. Light is form, since it is admitted to the nave only after it has been patterned by the colored network of the stained glass windows. To what realm, to what region in space do these structures, situated between heaven and earth, and pierced through and through by light, belong? The flat, but limitless expanse of the windows, their images, shifting, transparent, disembodied and yet held firmly in place by bands of lead, the illusory mobility of volumes that, despite the stubborn rigidity of architecture, expand with the depth of shadows, the interplay of columns, the overhang of many-storied, diminishing naves — all these are like symbols of the eternal transfiguration forever at work on the forms of life and forever extracting from it different forms for another life.

75

The builder, then, does not set apart and enclose a void, but instead a certain dwelling place of forms, and, in working on space, he models it, within and without, like a sculptor. He is a geometrician in the drafting of the plan, a mechanic in the assembling of the structure, a painter in the distribution of visual effects and a sculptor in the treatment of masses. He assumes these different personalities in different degrees, according to the demands of his own spirit and to the state of the style in which he is working. It would be interesting to apply these principles to a study of the manner in which this displacement of values behaves, and to see how it determines a series of metamorphoses that are no longer the passing of one form into another form, but the transposition of a form into another space. I have already noted its effects when, in referring to flamboyant art, I spoke of a painter's architecture. The law of technical primacy is unquestionably the principal factor in such transpositions — which, indeed, occur in every art. There consequently exists a sculpture exactly conceived for architecture or, rather, commissioned and engendered by architecture, and likewise, a sculpture that borrows its effects, and virtually its technique, from painting.

In a recent work, in which I attempted to give a definition of monumental sculpture, I had occasion to comment on these very ideas in order to make clear certain problems raised by the study of Romanesque art. It would appear at first sight that in order to understand properly the various aspects of sculptured form in space, we need only to distinguish low-relief, high-relief and full-round. But this distinction, which serves well enough to classify certain large categories of objects, is not only superficial, but captious in the plan of our present investigation. These large categories obey more general rules, and the interpretation of space is, as the case may be, equally applicable to reliefs or to statues. The character of sculpture must, in one way or another, be that of

a solid, irrespective of its protrusions and irrespective of whether it is composed on a single plane or as a statue around which one can move. Sculpture may indeed suggest the content of life and its inner articulation, but it is perfectly obvious that its design does not and cannot suggest to us anything resembling a void. Nor are we likely to confuse sculpture with those anatomical figures made up of parts indiscriminately thrown together into a single body that is no better than a kind of physiological carry-all. Sculpture is not an envelope. It bears down with all the weight of density. The interplay of the internal component parts has no importance save as it comes up to and affects the surfaces, without, of course, compromising them as the outward expression of the volumes. It is, to be sure, quite possible to analyze and to isolate certain aspects of sculptured figures, and this is something that a conscientious study should not omit. The axes establish movements: upon observing how many of them exist and how much they deviate from the vertical, we may interpret them just as we interpret an architect's plans for a building, with, of course, the reservation of their already occupying a three-dimensional space. The profiles are the silhouettes of the figure, according to the angle of our inspection from full front, from the rear, from above, below, right or left. The variations of these silhouettes are illimitable, and they "figure" space in a hundred different ways as we move about the statue. The proportions are a quantitative definition of the relationship between the parts, and lastly, the modeling translates for us the interpretation of light. Now, no matter how completely conjugate one recognizes these elements to be, no matter how little one loses sight of their intimate reciprocal dependence, they have no value whatsoever when isolated from the solid. The abuse of the word "volume" in the artistic vocabulary of our time is indicative of the fundamental need to recapture the immediate data of sculpture — or of sculptural qual-

ity. The axes are an abstraction. In considering an armature, that is, a mere sketch in wire endowed with the physiognomic intensity of all abbreviations, or in considering signs devoid of images, that is, the alphabet, or pure ornament, we realize that our *sight* must invest them all, for better or for worse, with substance. And it must do this in the twofold recognition, on the one hand, of their utter and terrifying nudity, and on the other, of the mysterious and vital halo of the volumes with which we must envelop them. The same thing applies to the profiles of sculpture – a collection of flat images, whose sequence or superposition elicits the concept of the solid only because the exigency already lies within ourselves. The inhabitant of a two-dimensional world might have before him an entire series of profiles for a given statue, and marvel at the diversity of such figures, without ever realizing that he was looking at but one single figure – in relief. Yet, if one admits that the proportions of a body imply their relative volume, obviously one can easily evaluate the straight lines, the angles and the curves without having to call into being any concept of space at all. Studies in proportion apply to flat figures exactly as they do to figures in relief. Finally, if modeling be interpreted as the actual life of the surfaces, then the various planes that compose it are not merely a garment draped across nothingness, but are, rather, the point at which the "internal mass" meets with space. To recapitulate, then: The axes account to us for the movements of sculpture, the profiles for the multiplicity of contours, the proportions for the relationship of parts and the modeling for the topography of light. But none of these elements, taken singly or in combination, can ever be substituted for the total *volume*, and it is only by keeping this idea closely in mind that the various aspects of space and form in sculpture can be rightly determined.

I should like to attempt such a distinction by differentiating

between space as a limit and space as an environment. In the first case, space more or less weighs on form and rigorously confines its expansion, at the same time that form presses against space as the palm of the hand does on a table or against a sheet of glass. In the second case, space yields freely to the expansion of volumes that it does not already contain: these move out into space and there spread forth even as do the forms of life. Space as a limit not only moderates the proliferation of relief, the excesses of projection, the disorder of volumes (which it tends to block into a single mass), but it also strongly affects the modeling. It restrains its undulations and disturbances; it suggests the modeling itself merely by an accent, by a slight movement that does not break the continuity of planes or, occasionally, as in Romanesque sculpture, by an ornamental setting of folds designed to clothe the bare masses (Figure 10). However, space as an environment, exactly as it delights in the scattering of volumes, in the interplay of voids, in sudden and unexpected perforations, so does it, in the modeling, welcome those multiple, tumbled planes that rend the light asunder. In one of its most characteristic states, monumental sculpture displays perfectly the consequences of the principle of space as a limit. This is in Romanesque art, which, dominated by the necessities of architecture, lends to sculptured form the significance of mural form. Such an interpretation of space, however, concerns not merely the figures that decorate the walls and that occur in a fixed relation to them. Space as a limit applies likewise to the full-round, over the masses of which it stretches a skin that guarantees solidity and density. The statue then appears clothed with an even, tranquil light that seems scarcely to move at all across the sober inflections of the form. Inversely, but still within the same order of ideas, space as an environment not only clearly defines a certain way of making statues, but it also affects those reliefs that attempt to express by all manner of devices the

79

semblance of a space wherein form moves freely. The baroque state of all styles presents innumerable examples of this. The skin is no longer merely an accurate mural envelope; it is quivering under the thrust of internal reliefs that seek to come up into space and revel in the light and that are the evidence of a mass convulsed to its very depths by hidden movements.

In a comparable manner, we may apply the same principles to the study of the relationship of form and space in painting, insofar, at any rate, as painting attempts to depict the solidity of objects in three dimensions. But painting does not, of course, have at its command this seemingly complete space; it only feigns it. Here is a further example of the final stage of a highly specific evolution; and even so, painting can display an object in but one profile. And yet, perhaps nothing is more extraordinary than the variations of painted space. This is especially true since we can give only an approximate idea of them, owing to our lack of a history of perspective, as well as of a history of the proportions of the human figure. In any case, it will at once be noted that these variations are not only a function of time and of various degrees of knowledge, but also of materials and substances, without the analysis of which every study of forms runs the risk of remaining dangerously theoretical. Illumination, distemper, fresco, oil painting, stained glass could not be realized in an unconditioned space: each of these techniques confers upon space a specific value. Without anticipating investigations that it has seemed best for me to pursue elsewhere, it may be here admitted that a painted space varies according to whether the light is outside the painting or within it. In other words, is a work of art conceived as an object within the universe, lighted as other objects are by the light of day, or as a universe with its own inner light, constructed according to certain rules? This difference of conception is, to be sure, again connected with the difference between techniques,

Figure 10. Voussoir: Angel playing musical instrument.

but does not absolutely depend upon it. Oil painting does not necessarily try to emulate space and light; miniature, fresco and even stained glass can construct a wholly fictitious light within an illusion of space. We must account for this relative liberty of space always with regard to the material in which it is realized, but we must account too for the perfect propriety with which space assumes such and such a figure in such and such a material.

I have spoken already of ornamental space. This important department of art is by no means one that commands all possible approaches, but it is one that has for many centuries and in many countries translated man's meditations on form. Ornamental space is the most characteristic expression of the high Middle Ages in the Western world. It is an illustration of a philosophy that renounces development in favor of involution, that surrenders the concrete world for the frivolities of fantasy, the sequence for the interlace. Hellenistic art had disposed about man a limited, exact space. It was a space, whether urban or rural, whether of a street corner or of a garden, that was still a "site," bucolic to a certain extent, and rich with elegantly combined accessories that served as a frame for trivial myths and for romantic fables. But as they hardened and became fixed forms incapable of renewal, the accessories themselves tended gradually to schematize the entire environment in whose topography they had once been but scattered landmarks. The vine branches and the arbors of Christian pastorals completely overran their landscape. They reduced it to a void. Ornament, resuscitated from primitive civilizations, dispensed with the dimensions of an environment that was degenerate and spineless; the ornament was, moreover, its own environment and its own measure. I have tried to show that the space of the interlace is neither flat nor motionless. It moves, since metamorphoses do occur under our eyes, not by distinct stages, to be sure, but within a complex continuity of curves, spirals and

entwined stems. It is not flat, since, like a river losing itself in subterranean regions and later reappearing above ground, the ribbons that compose these unstable figures pass beneath one another, and their outward, visible form on the plane of the image can be explained only by a secret activity on the plane below. This perspective of the abstract is, as I have said, notable in Irish manuscripts. But in that painting, it is discernible in far more than the mere play of the interlaces. Alternately light and dark combinations, like those on a checkerboard or irregular polyhedrons similar to isometric views of ruined cities or to visionary town plans, will, without the least suggestion of any shadow, occasionally give us the importunate, if fugitive illusion of a glittering relief. This is also the case with the meanders that are partitioned off by light or dark folds. Romanesque mural painting, chiefly in the western districts of France, retained some of these types of treatment in the composition of the borders. However rarely such treatments may occur in the figures themselves, at least the great monochrome compartments that make up the figures never juxtapose two equivalent values without inserting a different value between — although this is perhaps due simply to a necessity for optical harmony. But it seems to me that this practice, if followed with absolute constancy, would apply to the structure of the ornamental space whose curious perspective I have outlined above. Figures painted on walls can no more allow the illusion of projection and recess than the requirements of stability can authorize an excessive number of openings in the wall. And yet, when we observe a wall in its entirety, whatever purely tonal differences in ornament we may see still do suggest a certain relationship between the various parts of the wall. This relationship — if I may be allowed to indicate, by a contradiction in terms, the curious optical contradiction resulting from these differences — may be called flat modeling. Here, then, is further confirmation of

the idea that ornament is not a mere abstract graph evolving within any given space whatsoever. What ornamental form does is to create its own modes of space, or better, since our conceptions of form and space are so inseparably united, what they do is to create *one another* within the realm of ornament, with identical freedom respecting the object and according to identically reciprocal laws.

But however true it is that these terms are closely and dynamically united in the normative and classic state of every possible ornamental style, cases nevertheless exist where space remains only an ornament, while the object occupying it – as, for example, the human body – tends to emancipate itself. There are likewise other cases where the form of the object retains its ornamental value, while the space surrounding it tends to acquire a rational structure. The frequently troublesome concept of *background* in painting is a case in point, whenever, that is, nature and space are no longer an extension beyond man, or a periphery around him that both prolongs and penetrates his being, but are instead an entirely separate entity with which he is not in accord. In this respect, Romanesque painting occupies an intermediate position. Here, colored stripes, flat tones, scattered shapes, cloths hung across porticoes, all serve to cancel out the backgrounds. But the figures take their places logically, without isolation from the backgrounds, for, even if they are not strictly ornamental, that is, not held tightly within well-defined architectural frames, they are nevertheless primarily mere monograms and arabesques. There are, obviously, exceptions to this qualification: it does not apply, despite their elegance of profile, to the figurines in thirteenth-century Parisian Psalters. These figurines do not stem from some remote, impossible world, but are adapted to a wholly terrestrial life whose exigencies their beautifully articulated limbs and accurate proportions obey; and, even though more often than not they

are completely isolated within decorative architectural frames, they seem to step forward (in the fullest sense of the word) from backgrounds strewn with stars or embroidered with *rinceaux*. In spite of the difference in his manner, a similar observation could be made regarding Jean Pucelle and his little imaginary gardens, which contain elements strictly of this world, as well as fictions of an enchanting vivacity, both of which, however, are cut up like a grillwork of wrought iron and hung out on a standard over the empty margins (Figure 11). In a painted manuscript, as on a painted wall, the space continues to struggle against any purely make-believe emptiness, even while, at the very same moment, the form begins to assume a slight relief. On the other hand, examples of exactly the opposite are often met with in Italian Renaissance art. The work of Botticelli displays several very striking instances. He knows and practices — sometimes, of course, merely as a virtuoso — every device that permits the likely construction of linear and aerial space, but the beings who move within that space itself he does not completely define. They preserve a sinuous and *ornamental* line, certainly not that of any ornament known and classified in an index, but a line that might be described in the undulations of a dancer who, even in merely maintaining the physiological equilibrium of his body, is purposely seeking to compose such or such a figure. This unique — almost feudal — privilege long remained the property of Italian art.

Something analogous takes place within the caprices of fashion. Fashion may indeed attempt to respect, and even to expose, the proportions of nature. But more often it will submit form to incredible transmutations; it will create hybrids; it will impose on the human being the profile of an animal or a flower. The body becomes but the pretext, the support and sometimes only the material for utterly gratuitous combinations. Fashion thus invents an artificial humanity that is not the passive decoration of a formal

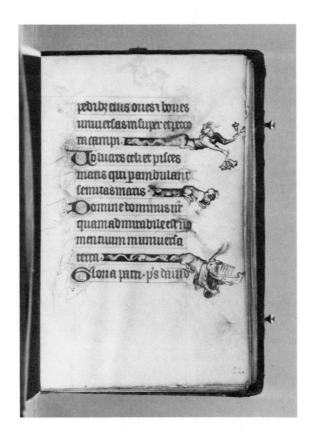

Figure 11. Pucelle: The Hours of Jeanne d'Evreux, Queen of France.

environment, but that very environment itself. Such a humanity, created in turn by heraldry, stage design, fantasy or architecture, obeys much less the rule of rational propriety than the poetry of ornament, and what fashion calls line or style is perhaps but a subtle compromise between a certain physiological canon (which is, moreover, highly variable, as are the successive canons of Greek art) and a pure fantasy of shapes. Arrangements of this nature have always fascinated those painters who at heart are costume designers, and many painters who are sensitive to the metamorphoses that concern the body as a whole are extremely susceptible to the decorative value of textiles. What is true for Botticelli (Figure 12) is no less true for Van Eyck (Figure 13). Arnolfini's enormous hat, atop his pale, alert little face, is far more than a mere headdress. In that endless twilight above and beyond time in which the Chancellor Rolin kneels at prayer, the brocaded flowers of his coat are of signal service in creating the magic of the place and of the moment.

These observations on the permanence of certain formal values furnish us with but one aspect of an extremely complex development. Before submitting themselves to the laws of sight itself, that is, before treating the picture image like the retinal image and combining the three dimensions in a two-dimensional plane, space and form in painting passed through many different states. The theory of the relationship between the relief of form and the depth of space was not defined on the spur of the moment, but was sought out through successive experiments and important variations. The figures of Giotto take their places as simple and beautiful blocks within a strictly limited environment, analogous to the workshop of a sculptor, or better, to the stage of a theater. A backdrop or a few flats, on which are indicated (less as real elements than as forcible suggestions) bits of building or of landscape, arrest the sight categorically and prevent the actual wall on which

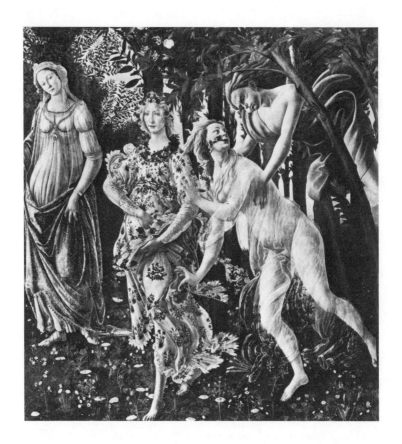

Figure 12. Botticelli: Detail from Primavera.

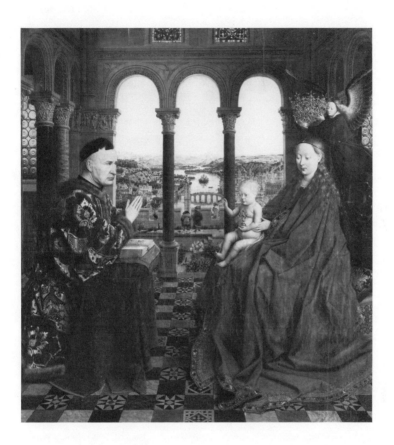

Figure 13. Van Eyck: Madonna with Chancellor Nicolas Rolin.

they are painted from being weakened by whatever illusory aper-
tures it may contain. It is true that at times this conception seems
to give way to another arrangement, one that indicates the neces-
sity of utilizing space not as a limit, but as an environment. An
admirable example is the scene of the Renunciation of Saint
Francis in the Bardi Chapel. Here the stylobate of the Roman tem-
ple is shown on the bias and consequently presents, on either side
of the leading edge, so distant a perspective that the entire mass
seems to be thrown forward and plunged directly into the space we
ourselves occupy. This is primarily, of course, certainly a device
of composition, intended to separate the figures unmistakably on
either side of a vertical line. But in any case, and in spite of their
gestures, the figures within this transparent, precisely limited vol-
ume are so utterly isolated from each other and from their envi-
ronment that they seem to exist in a void. It might be said that
they are being put to some sort of fiery trial whose purpose it is
to detach them from every equivocal similarity and every compro-
mise, to circumscribe them faultlessly, to insist on their weight as
separate entities. The followers of Giotto, we know, were far from
having been loyal to Giotto's own art in this respect. The sceno-
graphic space of that art — comparable to a space soberly estab-
lished for the needs of a popular theater — becomes with Andrea
da Firenze's treatment of the Spanish Chapel a field for abstract
hierarchies or an incidental support for compositions which fol-
low one another very loosely, while Taddeo Gaddi, on the con-
trary, seeks in the *Presentation of the Virgin*, but without quite
attaining his purpose, to "square off" the architectural setting of
the Temple of Jerusalem. In this connection, indeed, it may be
noticed that there are already proofs — long before the *prospettiva*
of Piero della Francesca in the picture gallery at Urbino — that
architecture, and not painting, is to be the mistress of those exper-
iments that lead to the discovery of rational perspective.

These experiments, however, do not immediately converge, but are preceded, escorted and often, for a considerable length of time, contradicted by diametrically opposed solutions. Siena, for instance, exhibits numerous examples of this. One may be the achievement of a sparkling denial of space: ancient backgrounds of gold, sprinkled with flowerets and arabesques, against which forms are outlined, sketched with a stroke as delicate as hand-writing — the ornamental space of an ornamental form that is struggling to be free. Or another may be the pageantry of verdure that, like a great tapestry, hangs behind scenes of the chase or of a garden. Or still a third (and the one that is perhaps the truly original element in the contribution of Siena to painting) may be the cartographic landscapes that display the world from the top to the bottom of the picture, not in depth, but in a bird's-eye view, not unlike a theater backdrop that has been made ready for the greatest possible variety of scenes. The need to grasp the totality of space is here satisfied by a wholly arbitrary and yet fertile structure — a structure that is neither the schematic abbre-viation of a ground plan nor a normal perspective, and that, inci-dentally, even after the final establishment of the latter, takes on a new vigor in the northern workshops of painters of fantastic landscapes. In an eye-level horizon, objects are hidden one behind the other, and distance, by progressively diminishing their size, also tends to efface them. But beneath a raised horizon, space unfolds like a carpet, and the shape of the earth is like the slope of a mountain. Sienese influences spread this system over all northern Italy, even though it was at the very time that Altichiero was seeking — by an entirely different process — to suggest by the gyratory rhythm of his compositions that the hollow of space was spherical. But, in Florence, the collaboration of geometricians, architects and painters led to the invention or, rather, to the adjustment of the proper machinery for reducing the three dimen-

sions to the data of a ground plan by calculating the correct relationships between them with the precision of mathematics.

One could hardly hope to retrace the genesis and the early
stages of this significant innovation in a brief treatise on method,
but it must nevertheless be borne in mind that, in spite of its
strict rules, the art of perspective was always, from the moment
of its discovery, a field open to many possibilities. Theoretically,
art henceforth stands in relation to the object, that is, *true* form
within a *true* space, exactly as sight itself stands in relation to the
same object, according to the system of the visual pyramid as
expounded by Alberti. And furthermore, the artist, by comprehending the work of the Creator in all its plenitude, exactness
and variety, thanks to the methodical collaboration of ground plan
and volume, becomes in the eyes of his contemporaries the man
most like God, or, at all events, he becomes a secondary and imitative god. The world that he makes is an edifice, viewed from a
single point and peopled by statues with a single profile: in such
wise, at least, is it possible to symbolize the roles played by the
architect and the sculptor in the new art of painting. But, constructed perspectives remain fortunately bathed in the memory
of imaginary perspectives. The great masters are entranced by the
forms of men and of all other living creatures realized according
to such means. For these, forms suffice to define *all* space, by the
relation of lights to darks, by the precision of movements and,
especially, by the accuracy of foreshortenings. These things the
masters never weary of studying from the figures of men and of
horses alike. And yet the landscapes that surround these figures –
the setting for the battles by Uccello, the setting for Pisanello's
Legend of St. George at S. Anastasia in Verona – still belong to a
visionary world of other times that spreads out behind the figures like an immense map or tapestry. And the figures, in spite
of the authenticity of their substance, remain but profiles. Their

value is, indeed, little more than that of silhouettes, with, as may be observed from the drawings in the Vallardi collection, a certain heraldic if not necessarily ornamental quality. The energy of the human profile in outlining upon the empty background a hard and fast line of demarcation — a frontier, as it were, between the worlds of actual life and of abstract space against which that profile is fixed — offers many further proofs. To this background, which, although empty, is yet so laden with secrets as to be an essential to man's existence, Piero della Francesca brings new interest, and to it he gives shape. Not only does he establish the normal type of the constructed landscape, the *prospettiva*, by offering such reassuring guides to reason as the shape of buildings reasonably put together, but he also seeks to define the variable relationship between atmospheric values and his figures. Sometimes the latter stand out in almost translucent clarity against the black distances; sometimes, with profiles modeled half in shadow, they stand out somberly against limpid backgrounds that bit by bit are flooded with light.

Beyond this it would not seem possible for us to go. The imaginary worlds of ornamental space, of scenic space and of cartographic space having rejoined the space of the real world, henceforth the life of forms must, it would seem, manifest itself according to unalterable rules. But nothing of the kind occurs. For, intoxicated by its own powers, perspective at once goes headlong to meet its objectives. By means of the *trompe-l'oeil*, perspective completely demolishes architecture and shatters its ceilings with one explosive apotheosis after another. It wipes out the boundaries of stage scenery by creating a false infinity and an illusory vastness. Perspective extends the limits of vision until the very horizon of the universe is exceeded. Here, we may see the principle of metamorphoses exploiting its deductions to the last possible limits; here, we may see it tirelessly evoking all manner

of new relationships between form and space. Rembrandt defines these relationships by means of light: he constructs around one dazzling point within a transparent twilight orbs and spirals and wheels of flame. El Greco's various combinations recall those of Romanesque sculptors. For Turner, the world is an unstable harmony of fluids, and form is a will-o'-the-wisp, an uncertain note in a universe forever in flight. An examination, therefore, no matter how cursory, of the various conceptions of space shows us that the life of forms is renewed over and over again, and that, far from evolving according to fixed postulates, constantly and universally intelligible, it creates various new geometries even at the heart of geometry itself. Indeed, the life of forms is never at a loss to create any matter, any substance whatsoever of which it stands in need.

Forms in the Realm of Matter

Unless and until it actually exists in matter, form is little better than a vista of the mind, a mere speculation on a space that has been reduced to geometrical intelligibility. Like the space of life, the space of art is neither its own schematic pattern nor its own carefully calculated abbreviation. In spite of certain illusions popularly held in regard to it, art is not simply a kind of fantastic geometry, or even a kind of particularly complex topology. Art is bound to weight, density, light and color. The most ascetic art, striving modestly and with few resources to attain to the most exalted regions of thought and feeling, not only is borne along by the very matter that it has sworn to repudiate, but is nourished and sustained by it as well. Without matter art could not exist; without matter art would be something it had never once desired to be. Whatever renunciation art makes of matter merely bears witness anew to the impossibility of its escaping from this magnificent, this unequivocal bondage. The old antitheses, spirit–matter, matter–form, obsess men today exactly as much as the dualism of form and subject matter obsessed men centuries ago. The first duty of anyone who wishes to understand anything whatsoever about the life of forms is to get rid of these contradictions in pure logic, even should they still retain some slight trace of

meaning or of usefulness. Every science of observation, and in particular that which is concerned with the movements and the creations of the human mind, is, in the strictest sense of the term, essentially phenomenological. And, because of this, the opportunity is given us of grasping authentic spiritual values. A study of the surface of the earth and the genesis of topographical relief, that is, morphogeny, supplies us with admirable foundations to the poetry of landscape, but such studies do not have that object originally in view.

The physicist does not take the trouble to define the "spirit" that underlies the transformation and behavior of weight, heat, light and electricity. Then, too, nobody any longer confuses the inertia of mass with the life of matter. This is because matter, even in its most minute details, is always structure and activity, that is to say, form, and because the more we delimit the field of metamorphoses, the better do we understand both the intensity and the graph of the movements of this field. These discussions of terminology would be futile, if they did not involve methods.

In my approach to the problem of the life of forms in matter, I do not mean to separate the one concept from the other, and if I use the two terms "form" and "matter" individually, it is not to give an objective reality to a highly abstract procedure, but is, on the contrary, in order to display the constant, indissoluble, irreducible character of a true and genuine union. If we will hold this notion in mind, it will be seen that form does not behave as some superior principle modeling a passive mass, for it is plainly observable how matter imposes its own form upon form. Also, it is not a question of matter and of form in the abstract, but of many kinds of actual matters or substances — numerous, complex, visible, weighty — produced by nature, but not natural in and of themselves.

Several principles may be deduced from the preceding. The

first is that all different kinds of matter are subject to a certain destiny, or at all events, to a certain formal vocation. They have consistency, color and grain. They are form, as I have already indicated, and because of that fact, they call forth, limit or develop the life of the forms of art. They are chosen not only for the ease with which they may be handled, or for the usefulness they contribute to whatever service art renders to the needs of life, but also because they accommodate themselves to specific treatments and because they secure certain effects. Thus, their form, in its raw state, evokes, suggests and propagates other forms, and, to use once again an apparently contradictory expression that is explained in the preceding chapters, this is because this form liberates other forms according to its *own* laws. But it must be pointed out at once that the formal vocation of matter is no blind determinism, for — and this is the second principle — all these highly individual and suggestive varieties of matter, which demand so much from form and which exert so powerful an attraction on the forms of art, are, in their own turn, profoundly modified by these forms.

Consequently, there is between the matters or substances of art and the substances of nature a divorce, even when they are bound together by the strictest formal propriety. A new order is established, within which there are two distinct realms. This is the case even if technical devices and manufactures are not introduced. The wood of the statue is no longer the wood of the tree; sculptured marble is no longer the marble of the quarry; melted and hammered gold becomes an altogether new and different metal; bricks that have been baked and then built into a wall bear no relation to the clay of the clay pit. The color, the integument, all the values that affect the sight have changed. Things without a surface, whether once hidden behind the bark, buried in the mountain, imprisoned in the nugget or swallowed in the mud,

have become wholly separated from chaos. They have acquired an integument; they adhere to space; they welcome a daylight that works freely upon them. Even when the treatment to which it has been submitted has not modified the equilibrium and natural relationship of the parts, the life that seems to inhabit matter has undergone metamorphosis. Sometimes, among certain peoples, the kinship between the substances of art and the substances of nature has been the subject of many strange speculations. The Far Eastern masters, for whom space is essentially the theater of metamorphosis and migration, and who have always considered matter as the crossroads where a vast number of highways come together, have preferred among all the substances of nature those that are, as it were, the most *intentional* and that seem to have been elaborated only by some obscure art. And yet, these same masters, while working with the substances of art, often undertook to stamp the traits of nature upon them; they attempted, indeed, to transform them completely. And thus, by a singular reversal, nature for them is full of works of art, and art is full of natural curiosities. Their exquisite little rock gardens, for example, although composed with the utmost care, seem to have been laid out by the mere caprice of some highly ingenious hand, and their earthenware ceramics appear to be less the work of a potter than a marvellous conglomerate created by subterranean fire or accident. In addition to this delightful emulation and to this interest in transpositions — which seeks the artificial at the heart of nature and the secret labor of nature at the heart of human invention — these men have been artisans who have worked only with the rarest of substances and who have been the most emancipated from the use of models. Nothing exists in either the vegetable or the mineral world that suggests or recalls the cold density, the glossy darkness, the burnished and shadowy light, of the lacquers made by these Eastern masters. These lacquers actu-

ally come from the resin of a certain pine, which is then long
worked and polished in huts built above watercourses and per-
fectly protected from all dust. The raw stuff of their painting
partakes both of water and of smoke, and yet is in reality neither
the one nor the other, inasmuch as such painting possesses the
extraordinary secret of being able to stabilize these elements and
at the same time to leave them fluid and imponderable.

But this sorcery, which astonishes and delights us because it
comes to us from afar, is no more captious or inventive than the
labor of Western artists upon the substances of art. The precious
arts, from which we might be first tempted to draw examples,
do not, perhaps, offer anything at all comparable in this respect
to the resources of oil painting. There, in an art seemingly dedi-
cated to "imitation," the principle of non-imitation appears as it
does nowhere else. There, in oil painting, lies the creative origi-
nality that extracts from the substances furnished by nature all
the matters and the substances necessary for a new nature. This
originality is, moreover, one that unceasingly renews itself. For
the matter, or substance, of an art is not a fixed datum that has
been acquired once and for all. From its very first appearance it
is transformation and novelty, because artistic activity, like a
chemical reaction, elaborates matter even as it continues the work
of metamorphosis. Sometimes in oil painting we observe the spec-
tacle of transparent continuity, of a retention of all forms, whether
hard or limpid, within a delicate, golden crystallization. Or again,
oil painting will nurture forms with gross abundance, and they
will seem to wallow and roll in an element that is never quies-
cent. Sometimes oil painting can be as rough as masonry, and
again it can be as vibrant as sound. Even without the introduc-
tion of color, it is obvious that the substance varies here in its
composition and in the *seeming* relationship of its parts. But when
we do call on color, it is even more obvious that the same red,

99

for instance, takes on different properties, not only according to its use in distemper, tempera, fresco or oil, but also a different property according to the manner of its application in each one of these various processes.

This observation serves to introduce several others, but before considering them, a number of points remain still to be clarified. One might reasonably suppose that there are certain techniques in which matter is of slight importance, that drawing, for example, is a process of abstraction so extreme and so pure that matter is reduced to a mere armature of the slenderest possible sort, and is, indeed, very nearly volatilized. But matter in this volatile state is still matter, and by virtue of being controlled, compressed and divided on the paper — which it instantly brings to life — it acquires a special power. Its variety, moreover, is extreme: ink, wash, lead pencil, charcoal, red chalk, crayon, whether singly or in combination, all constitute so many distinct traits, so many distinct languages. To be satisfied as to this, one need only imagine any such impossibility as a red chalk drawing by Watteau copied by Ingres in lead pencil or, to put it more simply (inasmuch as the names of individual masters introduce certain values that we have not yet discussed), a charcoal drawing copied in wash. The latter at once assumes totally unexpected properties; it becomes, indeed, a new work. We may at this point deduce a more general rule that invokes the principle of destiny or of formal vocation mentioned above, that is, the substances of art are not interchangeable, or in other words, form, in passing from a given substance to another substance, merely undergoes a metamorphosis.

The importance of this remark in connection with the historical study of the influence of certain techniques on other techniques can, it is hoped, henceforth be understood without difficulty. It was originally inspired by my attempt to establish a

critical approach to one particular, and very definite, idea of influ-
ence: that involving the relationships between the monumental
sculpture and the precious arts of the Romanesque period. An
ivory or an illumination, when copied by a muralist, at once
enters an altogether different universe — a universe whose laws
it must faithfully obey. The attempts made by mosaic and by
tapestry to take on the effects of oil painting have had familiar
consequences. And yet, the masters of interpretative engraving
clearly understood that they did not have to "compete" with the
paintings they were using as models (any more than painters com-
pete with nature), but simply to transpose them. It is, of course,
possible to elaborate these ideas much more fully. But at least they
help us to define a work of art as *unique*, for, the equilibrium and
the properties of the substances of art not being constant, no abso-
lute copy is ever possible, even within a given substance or at a
time when a given style is most firmly established.

I wish to insist again, in order to make myself perfectly clear,
on the fact that form is not only, as it were, incarnated, but that
it is invariably incarnation itself. It is not easy for us to admit this
readily. Our minds are so filled with the *recollection* of forms that
we tend to confuse them with the recollection itself, and there-
fore to believe that they inhabit some insubstantial region of the
imagination or the memory, where they are as complete and as
definite as on a public square or in a museum gallery. How can
certain measures that seem to exist wholly within ourselves, such
as the interpretation of space, or the relationship of parts in
human proportions and in the play of human movements, be mod-
ified by all the various kinds of matter, and depend on them as
well? One is reminded of the phrase Flaubert applied to the
Parthenon, "black as ebony." He wished, perhaps, to indicate an
absolute quality — the absolute of a measure that dominates mat-
ter and even metamorphoses it, or to put it more simply, the stern

authority of a single, indestructible thought. But the Parthenon is made of marble, and this fact is of extreme importance — so much so that the drums of concrete that have been inserted into the columns by respectful restoration seem no less cruel than mutilations. Is it not strange that a volume may change, as it assumes shape in marble, bronze or wood, as it is painted in distemper or oil, engraved with a burin or lithographed? Do we not risk confusing superficial and easily altered properties with others that are more general and constant? No, for the truth is that volumes, in these various states, are not the same, because they depend on light — on the light that models them, that brings out the solids or the voids and that makes the surface the expression of a relative density. Now, light itself depends on the substance that receives it. On this subject the light may flow easily or come firmly to rest; it may to a greater or lesser degree penetrate it; it may give it either a dry quality or an oily one. In painting, it is more than plain that the interpretation of space is a function of matter, which sometimes limits space and sometimes destroys its limits. Then, too, a given volume varies according to whether it is painted in full impasto or in superimposed glazes.

That our idea of matter should, therefore, be intimately linked with our idea of technique is altogether unavoidable. They are, indeed, in no way dissociated. I myself have made this concept the very center of my own investigations, and not once has it seemed to me to restrict them in any way. On the contrary, it has been like some observatory whence both sight and study might embrace within one and the same perspective the greatest possible number of objects and their greatest possible diversity. For, technique may be interpreted in many various ways: as a vital force, as a theory of mechanics or as a mere convenience. In my own case as a historian, I never regarded technique as the automatism of a "craft," nor as the curiosities, the recipes of a

"cuisine"; but instead as a whole poetry of action and (to pre-serve certain inexact and provisional terms used in the vocabu-lary of this particular essay) as the means for the achievement of metamorphoses. It has always seemed to me that in difficult stud-ies of this sort — studies that are so repeatedly exposed both to a vagueness of judgments respecting actual worth and to extremely ambiguous interpretations — the observation of technical phenom-ena not only guarantees a certain controllable objectivity, but affords an entrance into the very heart of the problem, *by present-ing it to us in the same terms and from the same point of view as it is presented to the artist.* To find ourselves in such a situation is as uncommon as it is desirable, and it is important to define wherein lies its interest. The purpose of the inquiries of a physicist or a biologist is the reconstruction of nature itself by means of a tech-nique controlled by experiment: a method less descriptive than active, since it reconstructs an activity. But we historians, alas, cannot use experiment to check our own results, and the analyt-ical study of this fourth "realm" which is the world of forms can amount to little more than a science of observation. But in view-ing technique as a process and in trying to reconstruct it as such, we are given the opportunity of going beyond surface phenom-ena and of seeing the significance of deeper relationships.

Thus formulated, this methodological position appears natu-ral and reasonable enough, and yet to understand it fully and above all to exploit its every possibility, we must still strive, within our inmost selves, to throw off the vestiges of certain old errors. The most serious and deeply rooted of these derives from that scho-lastic antinomy between form and subject matter, to the discus-sion of which there is no need to return. Next, even for the many enlightened observers who pay close attention to investigations on technique, technique remains not a fundamental element of knowledge that reiterates a creative process, but the mere instru-

ment of form, exactly as form seems to them to be the garment
and vehicle of the subject matter. This arbitrary restriction nec-
essarily leads to two false positions, and the second may be con-
sidered as the refuge and the excuse of the first. In regarding
technique as a grammar, which unquestionably has lived and still
does live, but whose rules have taken on a kind of provisional fix-
ity – a kind of value imparted by unanimous consent – we are led
to identify the rules of common speech with the technique of
the writer, the practice of a craft with the technique of an artist.
The second false position is to relegate every creative advance
augmenting that grammar to the indeterminate world of "prin-
ciples," in exactly the same way, for instance, as ancient medi-
cine explained all biological phenomena by the action of a vital
"principle." But if we no longer try to separate what is fundamen-
tally united, and instead try simply to classify and conjoin phe-
nomena, we see that technique is in truth the result of growth
and destruction, and that, inasmuch as it is equally remote from
syntax and from metaphysics, it may without exaggeration be
likened to physiology.

I do not deny that I myself am using the term under discus-
sion in two senses: techniques in particular are not technique in
general, but the first meaning has exercised a restrictive influence
on the second. It will be admitted that, in a work of art, these
meanings represent two unequal and yet intimately related aspects
of activity: that is, first, the aggregate of the trade secrets of a
craft and, second, the manner in which these trade secrets bring
forms in matter to life. This would amount to the reconciliation
of passivity with freedom. But that fact by itself is not sufficient,
for, if technique is indeed a process, we must, in examining a
work of art, go beyond mere craft techniques and trace to its
source an entire genealogy. This is the fundamental interest (supe-
rior to any specifically historical interest) that the "history" of a

work of art has for us before it attains its ultimate form — in the analysis, that is, of the preliminary ideas, the sketches, the rough drafts that precede the finished statue or painting. These rapidly changing, impatient metamorphoses, coupled with the earnest attention given them by the artist, develop a work of art under our very eyes, exactly as the pianist's execution develops a sonata, and it is of the first importance that we should take heed of them, as they move and react within something that is still apparently static. With what do they provide us? Points of reference in time? A psychological perspective? A jumbled topography of successive states of consciousness? Far more than these: What we have here is the very technique of the life of forms itself, its own biological development. An art that yields particularly rich secrets in this respect is engraving, with its different "states" of the plates. For the amateur, these states are mere curiosities; for the student they hold a much more profound meaning. When we examine a painter's rough draft — reduced to itself alone, and irrespective of its past as a sketch or its future as a painting — we feel that it already carries a genealogical significance and that it must be interpreted, not as an achievement in and of itself, but as an entire movement.

To these investigations on genealogy must be added those on variations and, also, those on interferences. As regards variations, it is plain that the life of forms often seeks different channels for itself within a single art and within the work of a single artist. Harmony and equilibrium are, to be sure, attained, but it is also true that this equilibrium is not only subject to disruption but that it may also invite new experiments. The question is much too easily simplified if we read into these nuances (which are, in reality, oftentimes perfectly distinct and clear) merely the poetic transposition of the tumults of human existence. For, what necessary relationship exists between the limitations, the physical

heaviness of old age and the youthful freedom that Tintoretto, Hals and Rembrandt (Figure 14) display at the end of their lives? Nothing exhibits better than do such powerful variations the impatience of technique in respect to its craft. It is not that matter oppresses technique, but that technique must extract from matter forces that are still vital and not vitrified beneath a flawless varnish. Nor is it, again, full possession of the "means to an end"; for, no longer are such means adequate. Nor is it, finally, virtuosity, since the virtuoso is above all else a kind of tightrope walker. So absorbed is he in his mastery over equilibrium that his dancing is but the endless repetition of the same step — a step whose rhythm he is in constant danger of losing as he slides back and forth along his thin, taut wire.

As for interferences, that is, the phenomena of chiasma and of exchange, these may be interpreted as a reaction against the formal vocation of the substances of art or, better, as a working of technique upon the relationships between techniques. It would be interesting to study the history of this process, in order to determine how the law of technical primacy would here behave, and how those notions of unity and necessity, that impose themselves to a greater or lesser degree on the various "crafts" of art, have been first built up and then overthrown both in practice and in teaching. It would, however, be much more profitable for us to pass over historical movements involving great ensembles and instead to analyze closely, and from this very point of view, the drawings and paintings of sculptors or the sculptures of painters. How is it possible, for example, to disregard Michelangelo the sculptor while studying Michelangelo the painter? How can one fail to perceive the close relationships that unite the painter and the etcher in Rembrandt? It is not enough to say that an etching by Rembrandt is simply a painter's etching (a concept that has itself undergone some remarkable variations); it must further be

Figure 14. Rembrandt: Gérard de Lairesse.

determined to what degree and by what means the etching strives to attain the effects – the specific and particular effects – of painting. Nor will it suffice to call attention to the light in Rembrandt's etchings when we are referring to his painting. We must instead carefully reconsider the various expert devices by means of which the former, because it has been transposed, acts on an entirely different substance, to whose sway it in turn submits itself. Another example is the relationship between watercolor and painting in the English school – a relationship that unquestionably derives from those extraordinary watercolorists in oil (if the expression may be allowed), Rubens and Van Dyck. For even though the fluidity of the substance in their painting is almost aqueous, there is as yet no question here of watercolor, properly speaking. How does this latter art achieve its particular definition? In what way does it attain a freedom sufficient to acquire its own formal "necessity"? How does it exercise on painters like Bonington and Turner the influence of such sparkling tonality and liquid clarity? The answers to these questions would reveal many unexpected aspects of the activity of forms. Substances are not interchangeable, but techniques penetrate one another, and, at the moment of their doing so, interference tends to create new substances.

But in conducting these investigations, we must do far more than merely maintain a general and systematic view of technique and a sympathy with the importance of its role. Our chief concern must be to account for its *behavior*. We must, in the truest sense of the word, follow closely at its heels; we must take careful note of how it lives its life. If we do not, it is obvious that any inquiry into genealogies, variations and interferences will remain superficial and precarious. At this point intervene both the tool and the hand. Let us, however, bear in mind that a mere descriptive catalogue of tools has, for our purposes, no value whatsoever, and that, if the hand be regarded as a physiological

tool, our studies will to a certain extent remain blocked: we would simply be analyzing so many type processes, such as those recorded in old-fashioned textbooks that were drawn up for rapid instruction in the art of pastel, oil or watercolor — in short, mere depositories, otherwise interesting enough, of cut-and-dried formulae. A very human familiarity exists between the tool and the hand. Their harmony is composed of the subtlest sort of give-and-take that cannot be defined by habit alone. This give-and-take allows us to understand that, once the hand conforms to the tool, once the hand has need of this self-extension in matter, the tool itself becomes what the hand makes it. The tool is more than a machine. Even if its very form already postulates what its activity is to be, even if its form indicates a definite future, that future is still not absolutely predestined. If it is, a revolt at once occurs. A nail may be used for engraving. And yet this same nail has a form as a tool and can produce other forms worthy of consideration. Should the hand rebel, it is through no desire to do away with the tool, but instead to establish a reciprocal possession on new foundations. That which acts is in its turn acted upon. To understand these actions and reactions, let us abandon the isolated consideration of form, matter, tool and hand, and instead take up our position on the exact, geometric meeting place of their activity.

The term that best describes the vigor of this "quadruple alliance," and that gives to it an instantaneous impact, is borrowed from the language of painting — namely, the touch. This term may, I think, be extended to include both the graphic arts and sculpture. It represents a single moment in which the tool awakens form in the substance, and it represents permanence, since because of it form has structure and durability. The touch does, to be sure, conceal what it has done: it becomes hidden and quiescent. But, underneath any hard and fast continuity as, for exam-

ple, a glaze in painting, we must and we can always detect it. Then it is that a work of art regains its precious living quality. It becomes an entity, well organized in all its parts, solid and insep- arable; it does not, as Whistler remarks, "buzz." But far more than this, it bears the indestructible (albeit hidden) traces of ardent and vigorous life. The touch is the true contact between inertia and action. When it falls perfectly evenly and indeed almost invisibly, as in the illuminations of pre-fifteenth-century manu- scripts, or when it seeks to give, by very close juxtaposition or even by fusion, not a sequence of vibrant notes, but, so to speak, a "layer" – single, bare and smooth – the touch may seem almost to have annulled itself, but it nevertheless remains a definition of form. As I have already said, a value, a tone do not depend alone on the properties and the relationships of the elements composing them, but on the way in which they are placed, that is, "touched." Because of this, a painting is not the same thing as a painted barn door or wagon. Touch is structure. It imposes on the form of the animate being or the object its own form, which is not merely value and color, but also (in no matter what min- ute proportions) weight, density and motion (Figure 15). The touch may be interpreted in sculpture in exactly the same way. I undertook earlier, in discussing a certain analysis of space, to dis- tinguish between two kinds of working procedures in sculpture: one which, starting from the surface, seeks for the form within the block (Figure 16), and one which, starting from the inner armature, builds it up gradually until the form is fully revealed. The first procedure, that of direct carving, consists of touches that become progressively closer as well as better unified by a more intimate interlocking of relationships. This is equally true of the second, or additive procedure, in which even the sculptor who is interested only in the relationships of volume and the equilib- rium of masses, and indifferent to studied and pedantic effects

in his modeling, has nonetheless "touched" his statue, and characterized himself by an economy of touch, as has the first sculptor by his prodigality.

There is no reason, I think, why the use of this term could not be safely extended even to architecture — at least in the study of visual effects, and certainly its use would be legitimate when we are dealing with those periods and styles in which pictorial values are predominant. One's impression then is that the monuments were kneaded and modeled by hand, and that the hand has left a direct imprint. It would be interesting to verify the fact that, as there is reason to believe, an identity of touch may somehow be clearly observed in all the different arts that exist under the same circumstances in the life of styles; and in what measure this identity (one that it is not easy to define) does or does not determine more general interferences than those to which I have already alluded.

But the term under discussion runs a certain danger: that of having always a special and restricted value, and we must remember that it implies the sense of *attack* on and treatment of matter, not outside of, but within, a work of art. In this respect, the study of engraving can be most illuminating. This is not the place to examine all its complicated processes, nor to investigate the details of its physics and its chemistry. Let it be enough to say that the substances of engraving, simple as they seem at first sight, are in fact numerous and complex. In burin engraving, for example, there is the copper of the plate, the steel of the tool, the paper of the print and the ink of the impression. Long before the hand takes them over, each one of these elements admits of great variety, and when the hand is at work with them, it obviously modifies more or less the relationship among their essential data. Even in those engravings whose technique is absolutely stable, it is still clear that the engraved substance itself is extraordinar-

Figure 15. Daumier: The Laundress.

Figure 16. Michelangelo: Captive.

ily diverse. Certain plates reek of the tool and preserve a metal-
lic aspect that others entirely conceal or, at least, fail to show
beneath the richness or the modulation of the workmanship. That
striking abstraction, *Raphael's Dream*, which, by reducing to a sim-
ple diagram the genius of the great painter, imparts to it a sud-
den poignant austerity, surely has nothing in common with the
almost sensual unction of Edelynck.

Let us, again, take the case of etching. Here, even without
considering the question of the interrelation of papers and inks,
we see before us, because of the etcher's obsession with light, the
construction of a three-dimensional world. A new element, acid,
makes the incisions deeper or shallower as the case may require; it
pulls them together or spreads them apart with a certain planned
irregularity in its biting into the plate that lends to the tone a
warmth wholly unknown in any other process. As a result, two
identical lines, reduced simply to themselves, and with no sug-
gestion of any shape whatsoever, are two different forms if one is
engraved and the other etched. The tool too has changed; it now
has merely a simple point and is held and used like a pencil, in
contrast to the steel blade of the burin, which, prismatic in shape
and cut with a beveled edge, is drawn across the plate from back
to front by a single motion of the wrist. Here again is the formal
vocation of matter and tool, but the touch, that is, the attack on
matter by the tool, keeps abreast of the true purpose of etching
and wrests therefrom some singularly original innovations. This
it does by a number of cunning devices, the best examples of
which have been furnished us by Rembrandt; among others may
be mentioned his superimposition in drypoint of line upon line
(whether scraped down and smoothed off or not), which secures
those exquisite effects of transparent light or of velvety darkness
(Figure 17). Sometimes Rembrandt etches as if he were drawing
with a pen, with a more or less free and open line, and some-

Figure 17. Rembrandt: Christ Crucified Between the Two Thieves.

times as if he were painting — struggling then to master by means of glittering spirals and mysterious, leaden shadow the entire scale of values. Repeated reprintings will weaken, deaden and eventually expunge everything from structures as fragile as the etcher's plates. Worn plates, indeed, preserve only the bottom courses of the once unblemished work, as an ancient city, now flush with the ground, discloses merely the general plan of its buildings. It is a kind of reverse genealogy, a kind of inverted assay of the rich resources of that which has passed away. The iconographer and the historian may believe that the essential still persists, but it has long since departed — not merely the bloom, the delicate charm of the completed etching, but everything that is fundamentally valuable and essential to an art that constructs space and form in terms of a specific light, in a specific substance and by specific touches. Thus, because a masterpiece has been destroyed before our very eyes, the realization inevitably arises in our minds of how active and how animate a concept is that of technique.

Forms in the Realm of the Mind

Up to this point, I have dealt with form as an independent activity, and with a work of art as a fact entirely separated from the causal complex. Or better, I have attempted to point out, in the system of particular relationships in which form is active, a kind of specific causality that first needed definition. The wonderful series of phenomena that form develops in space and in matter both authorizes and demands a very special order of studies. These phenomena – properties, movements, measures, metamorphoses – are not secondary indices, but the primary object of consideration. I am confident that I have said enough about them, despite the intentional brevity of this discussion, to dispel the impression that the notion of a *world* of forms is mere metaphor and to justify, in its main outline, my use of the methods employed by biology. And, too, I am fully aware of the criticisms raised by Bréal against every science of forms that "realizes" form as such and that construes it as a living entity. Where, within this multifarious, and yet highly organized world, are we to consider mankind as standing? Have we left in it room for the mind? We must cease this weaving of psychological metaphors; we must withdraw from the shelter of vocabulary and return directly to the source. Do not these forms that live in space and in matter

live first in the mind? Indeed, is it not that they live truly, as it were, uniquely, in the mind, and that their external activity is but the projection of some inner process?

Yes, forms that live in space and in matter do live in the mind. But the important question is to know what they do there, how they behave, where they come from, through what stages of development they pass and, finally, what turmoil or activity they undergo before taking shape, if, at least, it is true that being forms, even in the mind, they can have no "shape." This is a vitally essential aspect of the problem. Do these forms sit enthroned like great goddesses in some remote region from which they descend to us only when we call to them? Or are they born of a more humble seed, out of which they evolve very slowly, like animals? Are we to believe that, in those still unmeasured and mysterious realms of the spiritual life, forms are enriched by forces to which we can put no name — forces that seem forever to have secured for these forms the prestige of the unaccountable and the new?

When these questions are presented in this way, it is not always easy to find a satisfactory answer to them, in that they both presuppose and respect a certain fundamental antagonism. It is one that we have already run up against, and one that I have already tried to set at rest. It is my belief that there is no antagonism whatsoever between mind and form, and that the world of forms in the mind is identical in principle with the world of forms in space and matter: they differ only in plan or, possibly, in perspective.

Human consciousness is in perpetual pursuit of a language and a style. To assume consciousness is at once to assume form. Even at levels far below the zone of definition and clarity, forms, measures and relationships exist. The chief characteristic of the mind is to be constantly describing *itself*. The mind is a design that is in a state of ceaseless flux, of ceaseless weaving and then unweaving, and its activity, in this sense, is an artistic activity. Like the

artist, the mind works on nature. This it does with the premises that are so carelessly and so copiously offered it by physical life, and on these premises the mind never ceases to labor. It seeks to make them its very own, to give them mind, to give them *form*. This labor is so strenuous that sometimes the mind can do no more. All that it then seeks or needs is to relax, to lose willingly all sense of form, to accept passively whatever may flow up to it from the ocean depths of life. The mind, at such a time, believes that it can find rejuvenation in mere brute instinct, in the admission of fugitive impressions and of idle floods of emotion that have no true emotion in them. It breaks the old molds of language; it overturns the checkerboard of logic. And yet, these riots and tumults have no object other than the invention of new forms, or rather, their confused, turbulent activity is but another operation on forms, a formal phenomenon. I am convinced that it would be not only possible but highly useful to build up a psychographic method based on these various habits of the mind. In such a method, we might also include the notions pertaining to technique and to touch proposed in the preceding chapter.

Now the artist develops, under our eyes, the very technique of the mind; he gives us a kind of mold or cast that we can both see and touch. But his high privilege is not merely that of being an accurate and skillful molder of casts. He is not manufacturing a collection of solids for some psychological laboratory; he is creating a world — a world that is complex, coherent and concrete. And because this world exists in space and matter, its measures and laws are no longer those of the life of the mind in general, but measures and laws that are highly specialized. Perhaps, in our secret selves, we are all artists who have neither a sense of form nor hands. The characteristic of the true artist, however, is that he does have hands and that, in him, form is perpetually in conflict with them. Form is always, not the desire for action, but

action itself. Form cannot withdraw from matter and space, and, as I shall try to show, even before it takes possession of matter and space, it already exists within them. The realization of this fact by the artist is what distinguishes him from the common man and, even more so, from the intellectual. For, the common man is not a god who creates separate worlds; he is no specialist in the invention and fabrication of what seem to him to be mere utopias of space, mere fabulous playthings. And yet, he never loses a certain innocence, a certain wonderment, that might otherwise be tarnished by what is known as taste. The intellectual, on the other hand, in his approach to reality does have a technique, and it is the technique of logic. For this reason, he subconsciously despises the artist's technique, because he tends necessarily to make every activity conform to the processes of rational discourse. The very moment we attempt to define exactly what is original and irreducible in the technique of the artist's mind, we become aware of how difficult and how fatiguing such an effort is. We must, nevertheless, set down the various stages of artistic behavior in the plainest and most intelligible words. We must seek the very essence of the artist; we must try to be as he is himself. And yet, by eliminating that which he is not, do we not despoil him of his own rich human quality? It is possible that we do, at least when we try to demonstrate his dignity as a thinker — even though as the thinker of a specific thought, he himself might consider that he had lost caste. It is nevertheless by pursuing this course, and this course alone, without the least deviation from it, that we can ever hope to arrive at the truth. The artist is not the aesthetician, not the psychologist, not the art historian; as the need arises, he could, of course, be all these, and more. But the life of forms in his mind is not the same as the life of forms in the minds of such men, nor is it at all the same as that which arises in the mind of even the most

accomplished critic as he retraces the course laid out for him by the artist.

Is the life of forms in the artist's mind characterized, then, by the abundance and the intensity of its images? One would be inclined to think so at first: to picture such a mind as completely filled with and illuminated by brilliant hallucinations, and to interpret a work of art as the practically passive copy of some inner "work." This may be true in certain cases. But in general, richness, power and freedom of image are by no means the exclusive characteristics of the artist. Oftentimes, he is seriously lacking in these qualities, while among the rest of us those who possess them are much less rare than one would suppose. We all dream. In our dreams, we invent not only a sequence of circumstances and a dialectic of events, but also beings and nature, all set down in a space of the most haunting and illusory authenticity. Involuntarily we will paint pictures of landscapes and hunting scenes, or write plays about battles and pillage. In the course of a night, we could fill an entire museum with sudden and startling masterpieces of fabulous implausibility which depend in no wise on any solidity of mass or justness of tone. Memory likewise places at the disposal of each one of us a richly stocked storehouse. Even as waking dreams bring the works of visionaries to life, so too does the education of the memory foster in certain artists an inner form that is neither an image, properly considered, nor even pure recollection, but a form that allows these artists to free themselves from the tyranny of the model. But the recollection thus "formed" possesses special properties; a kind of inverted memory composed of deliberately forgotten things has already been at work. Deliberately forgotten to what ends and by what means? We are entering another realm than that of pure memory and imagination. We at once become aware that the life of forms in the mind is not copied from the life of images and of recollections.

121

Images and recollections are wholly sufficient unto themselves. They are made up of certain unknown acts that reside exclusively in the twilight realms of the mind. In order to attain completion, they do not need to emerge from this realm. Indeed, should they do so, their sparkle and durability would be imperiled, since the art of images, brusque and boisterous, contains all the inconsistencies of liberty, and the art of recollections, insidious and slow, prosily designs its fugues on the theme of time. From anything connected with this state of affairs, form insists on withdrawing. Its very externality, as we have seen, is its innermost principle; its life in the mind is simply a preparation for its life in space. Even before separating itself from thought, and entering into extent, matter and technique, form *is* extent, matter and technique. Form is never nondescript. Just as each of the various kinds of matter has its formal vocation, so has each form its material vocation, already plotted out within the inner life. In that life it is still impure, that is, unstable, and so long as it has not been born, that is to say, externalized, it is in continual movement, deep within the maze of tests and trials out of which experimentation is seeking the proper egress. This is what distinguishes it from the complete and compelling images of a dream. Prior to its birth, form is analogous to those drawings that seem to be struggling to attain their line and their poise — drawings whose inanimateness is so complex that they appear to be filled with animation. But simply because these aspects of form do not seem to obey — as yet — any fixed and irrevocable choice, they are neither necessarily vague nor indifferent. As intention, as wish and as presentiment, no matter how stenographic or fugitive, form calls forth and possesses even in these prenatal states its technical attributes, properties and prestige. In the mind, it is already touch, incision, facet, line, already something molded or painted, already a grouping of masses in definite materials. It is not, it

cannot be, abstract. As such, it would be nothing. It calls importunately for the tactile and the visual. Even as the musician hears, in his own ears, the design of his music not in numerical relationships, but in timbres, instruments and whole orchestras, so likewise the painter sees, in his own eyes, not the abstraction of his painting, but the tones, the modeling and the touch. The hand that is in his mind is at work. It creates the concrete within the abstract, and weight within the imponderable.

I may call attention once again to the profound difference that separates the life of forms from the life of ideas. Both have one point in common that sets them apart from the life of images and the life of recollections, that is, they are organized for action, they combine a special order of relationships. But it is clear that, if there is a technique of ideas and if it is impossible to separate ideas from their technique, this latter can be measured only in its own terms, and its relation to the outer world is still but an idea. Now, the idea of the artist is form. His emotional life turns likewise to form: tenderness, nostalgia, desire, anger are in him, and so are many other impulses, more fluid, more secret, oftentimes more rich, colorful and subtle than those of other men, but not necessarily so. He is immersed in the whole of life; he steeps himself in it. He is human; he is not a machine. Because he is a man, I grant him everything. But his special privilege is to imagine, to recollect, to think and to feel in *forms*. This conception must be extended to its uttermost limit, and it must be extended in two directions. I do not say that form is the allegory or the symbol of feeling, but, rather, its innermost activity. Form activates feeling. Let us say, if you like, that art not only clothes sensibility with a form, but that art also awakens form in sensibility. And yet, no matter what position we take, it is eventually to form that we must always come. If I were to undertake (which it is not my intention to do) the establishment of a psychology for the

artist, I should have to analyze formal imagination and memory, formal sensibility and intellect; I should have to define all the processes whereby the life of forms in the mind propagates a prodigious animism that, taking natural objects as the point of departure, makes them matters of imagination and memory, of sensibility and intellect — and it would then be seen that these processes are touches, accents, tones and values. The Baconian definition of *homo additus naturae* is vague and incomplete; it is not a question of a nondescript *homo*, of man in general, nor is it a question of a nature that is separated from man and that accepts his presence with a lofty indifference. Between nature and man form intervenes. The man in question, the artist, that is, forms this nature; before taking possession of it, he thinks it, feels it and sees it as form. The etcher sees it as etching, and chooses from it what may already be of technical profit to him. With Rembrandt, this is perhaps the lowly stable lantern that he takes with him into the innermost depths of the Bible; with Piranesi, it is the Roman moonlight with which he alternates light and shadow on his ruins, it is his obvious inability to find in the day-time, because he was a theater painter, any moonlight that would be comparably favorable to the artifices and absurdities of theatrical perspective. The painter of halftones, again, turns to the rain and the fog which serve to harmonize his values: before him is a curtain of water, and he sees everything through it; whereas the painter of bright colors, such as Turner, has before him the glass of water in which he dips his brush, and he sees the sun — tenfold, refracted and swift — within it.

Does this not give rise to the assumption that the life of forms in the mind is governed by a strict, indeed a flawless constancy? That in the mind it has established a predestination so rigid that, along with man, a whole other human species is brought into being, articulated in a special fashion and consecrated to its des-

tiny, exactly as an animal species might be among other species? By no means: The relationships between the life of forms and the other activities of the mind are not constant; we cannot give to them any ultimate definition. And, just as we must take technical interferences into account in order to understand the play of forms in matter, so must we never forget how great is the diversity of structure and of tonality in the composition of different minds. In certain minds, memory is predominant. With a mere imitator, a reliance on memory narrows the field of metamorphoses; with a virtuoso, such a reliance does not necessarily diminish their intensity in any way. To a visionary, the sudden, imperious nature of an image seems to impose itself on the life of forms with no little violence. There are, finally, those intellectuals who strive to think of form as thought and to adapt its life to the life of ideas. Indeed, should we examine the whole gamut of varying temperaments, we would have no difficulty in recognizing that the life of forms is undoubtedly more or less affected by the temperament – so much so that, having reached a certain point in our analysis, we would be tempted to have recourse to a kind of graphology.

But still another element must be added to the diversity of relationships between the man within the artist and the artist himself, and this depends exclusively on the order of forms. (I am using the word "order" here as would a biologist.) In a previous chapter, I laid stress on what I called the formal vocation of the substances of art, by which I meant that within these substances a definite technical destiny is implicit. To this vocation of substances, or technical destiny, there is a corresponding vocation of minds. The fact has already been made clear that the life of forms in the flat space of the mosaicist is not the same thing that it is in the constructed space of Alberti, or the "space as a limit" of the Romanesque sculptor and the "space as an environment" of Bernini. There is no similarity between the life of forms

in the substances of painting and in those of sculpture, impasto, glazing, carved stone and cast bronze, nor is there any between wood engraving and aquatint. Now, a certain order of forms corresponds to a certain order of minds. This is not the place to explain the reasons for this correspondence, but it is of the utmost importance to note it. Let me say once again that these things simply happen in life. They arise from little, unpremeditated movements as much as from experience; they imply an element of chance, even of adventure. I am not here describing phenomena of a physical order that may be made to recur in a laboratory, but more complex facts whose general graph is subject to very great fluctuation. Errors, tergiversations, failures will affect the curve of this graph, even though they do not affect its meaning, which, indeed, they may even confirm. The sculptors who see as painters and the painters who see as sculptors not only furnish examples, as we have observed above, for the principle of interferences, but they also demonstrate the immense power of the vocation under discussion by its resistance to any kind of opposition. In certain cases, the vocation recognizes or at least anticipates its material; it sees it, but does not yet have power over it. For technique is not ready made. It must be lived; it must work upon itself. A striking example of this foresight, impatient to learn from and outpace experience, may be found in the early career of Piranesi. When still the pupil of the Sicilian, Giuseppe Vasi — a competent, although thoroughly academic engraver — Piranesi asked his master to give him the secret of "true" etching, and when Vasi was unable, because of his limited capabilities, to reveal it, it is said that the apprentice flew into a violent rage. Another admirable illustration of this conflict between an all-consuming vocation and a material not yet fully realized is to be found in the first states of Piranesi's *Prisons* (Figure 18). The skeletal structure of these states is powerful enough, but as etchings they still

stay at the surface of the copper. They have not yet grasped and defined their own substance. The point of the tool seems to be whirling about with feverish speed in all directions, without biting into the material and penetrating it. The lines are tossed here and there in a grandiose attempt to portray colossal buildings that have neither weight nor mystery. But twenty years later, Piranesi returned to these etchings (Figure 19), and on taking them up again, he poured into them shadow after shadow, until one might say that he excavated this astonishing darkness not from the brazen plates, but from the living rock of some subterranean world. The mastery is at last total, absolute, and the difference between the artist's earlier effort and his later one may be accurately measured.

The life of forms *within* the mind is therefore not a formal aspect of the life of the mind. Forms always are tending toward realization; they do, in fact, realize themselves and create a world that acts and reacts. The artist beholds his work with other eyes than we do — we who must nevertheless make every effort to resemble him — for his vision is from within the forms, so to speak, and from within himself. Forms never cease to live. In their separate state, they still clamor for action, they still take absolute possession of whatever action has propagated them, in order to augment, strengthen and shape it. They are the creators of the universe, of the artist and of man himself. To define these relationships exactly, I would be obliged to adduce example upon example and to establish a far richer and more appropriate terminology than the one now at my disposal. The complexity of so vast a panorama may already be surmised. The life within the artist's mind develops on many planes, all of which are nevertheless connected by various bridges, corridors and stairways. These are thronged with all that inhabits his mind: travelers, so to speak, coming and going, ascending and descending, laden with most

Figure 18. Piranesi: The Prisons *(early state).*

Figure 19. Piranesi: The Prisons *(late state).*

extraordinary burdens. They long with a passionate urgency to put the great treasure chamber of the mind behind them, to come forth into the light of day and into those earthly regions from which, sometimes, they again return to the mind, gilded with a new light and ready to live a new and magical life. Every day that this life is lived it grows richer and richer; and herein lies the difference between the old age of the artist and the decrepitude of the rest of mankind.

To summarize: Forms transfigure the aptitudes and movements of the mind more than they specialize them. Forms receive accent from the mind, but not configuration. Forms are, as the case may be, intellect, imagination, memory, sensibility, instinct, character; they are, as the case may be, muscular vigor, thickness or thinness of the blood. But forms, as they work on these data, train and tutor them ceaselessly and uninterruptedly. They create a new man, manifold and yet unified, out of animal man. They press down with a weight that is never burdensome, because it is that of the very substances of art; they erect within thought an area that is never a vacuum, because it is a space created by consent or volition; they legislate a dialectic that is never a mere game, because true technique is creative activity. At the crossroads of psychology and physiology, forms arise with all the authority of outline, mass and intonation. If for a moment we cease to regard them as anything but concrete and active forces powerfully at work among the *things* of matter and space, we will find ourselves touching in the mind of the artist no more than the larvae of images and recollections, or at best the most rudimentary gestures of instinct.

Two conclusions may be drawn from the preceding remarks. One concerns the temporal life of artists, the other concerns groups or families of artistic minds.

First. The activities of great men inevitably hold for us a certain mysterious prestige, a certain secret element whose key we are forever trying to discover among the details of their lives. We make use of incident and anecdote both as documentary and as fictional material, and out of them we build up heroic portraits and truthful fables alike. The gold of biography must, we say, glitter as brightly as possible, even when it is veiled in shadow or covered with dust. Now, each life is its own piece of fiction, that is, a sequence and combination of adventures. There is, however, a limited number of such adventures — so much so that it would be a very easy matter to compile a catalogue of given dramatic situations. What changes much more than these adventures themselves is their tone, according, that is, to what we make of them. There happens in the life of each one of us something roughly analogous to that which happens in the written novel — which, it must be remembered, is by its very nature impoverished and which has repeated, both from its own beginnings and from those of life in society, a remarkably small number of stories. But on this slender armature, what a wealth of metamorphoses, what a variety of types and myths, of atmosphere and tone! We too, tied down within the same narrow limits, create our own myths, our own style, with greater or lesser relief and authority. And so also must the artist proceed with his prosaic novel. Reduced to a police dossier or to a paragraph in a dictionary, how commonplace do the facts seem. Here, for example, we have Chardin, perfectly contented to remain within the modest circle of a narrow bourgeoisie, or Delacroix, buried in his lonely studio, or Turner, deliberately hiding himself behind an incognito as protection against outward circumstances. Men such as these seem to limit the ordinary course of existence to a perpetual alibi, the better to welcome the essential events that originate in the life of forms. The smallest stage is adequate for their purposes, but if they ever

enlarge it, the need to do so comes from form within the mind. Hence their travels, which transport them not only in space but also in time. Hence, as we shall see later, their creation of the necessary environment. Sometimes a life may be a double one: that of Delacroix is a notable example of this. His everyday life is confined within the four walls of a remote retreat; his unreal and episodic "humanity" develops in very different surroundings. All night long he is in the midst of society, and all day long he is at work: both these operations being undertaken on the most heroic scale. The man in him worships the poetry and music that least correspond to his painting, even while the "man of taste" in him bewails and deplores that very painting. But since, happily, Delacroix is also a man of thought, he proceeds to explain how the two Delacroix live together in intimate unity. No text could display better than does his *Journal* the imperious dominion of forms over a mind: how, from a great man, forms take and then give all to us. The lives of certain artists do, it is true, seem to demand, nay, to anticipate all the many events of human life, and to be so utterly and ardently absorbed in their own times that this dominion of forms is never exercised over them. And yet Rubens, the diplomat and the producer of public festivals, delighted in the creation of pageants – of paintings, that is, not fashioned with canvas and brush. For, this particular family of minds has always taken actual, outward life as a plastic material on which it loved to impose, through the medium of feasts and parades and balls, its own form. The substance of art is then human life itself. In a more general way, the artist faces life exactly as Leonardo da Vinci faced the ruined wall that had been ravaged by time and weather, shaken by earthquake, stained by the waters of earth and sky, defaced by a thousand cracks. The rest of us see in this wall only the marks of ordinary circumstances. The artist sees in it figures of men separately or in groups, battles, land-

scapes, crumbling cities — forms. They powerfully affect his trained eyes and are unraveled and rebuilt. They affect or should affect likewise the analysis we make of the artist's life, where above all else the fact is form. Because of this we cannot write the biography of Rembrandt as we would write that of Burgomaster Six; we cannot trace that of Velasquez from the pattern of Philip IV; we cannot cut the life of Millet from the same cloth as that of such an inferior, though in his own way genuine, artist, as Charles Blanc.

Second. And yet, if we must seek out the bonds and ties that do exist between these men, we will see that throughout the whole course of their lives, their relationship is much less defined by circumstances than by affinities of mind regarding forms. In asserting that a certain order of minds corresponds to a certain order of forms, we are of necessity led to accept the notion that there must exist whole families of the mind or, as it were, families of form. It is not enough simply to say that there are intellectual artists, sensitive artists, imaginative artists, melancholy artists, irascible artists. To try to bring these natures and characters into conformity from within would be extremely dangerous. Phenomena in space must be the point of departure. Such phenomena always enter into the definition and classification of other men. And yet, confused and transitory as are the traces of all ordinary action, every act is still a gesture and every gesture a kind of hieroglyph. These gestures and hieroglyphs are a matter of the first importance, and if it be true, as James has shown, that every gesture exercises on the life of the mind an influence that is none other than the influence of *all* form, then the world created by the artist acts on him, acts in him and acts on other men. The god is created by his own nativity. Now, a static, machine-like concept of a technique that excludes all metamorphoses would bring about serious confusion between school and family. But within the same school — a school, that is, where the same processes are

taught — there is a difference of formal vocation: new forms as well as reconstituted ones struggle laboriously with themselves, and action strives for genesis and development. It is here that one sees men of the same stamp recognizing and calling out to one another. Human friendship may intervene in these relationships and further them, but the play of receptive affinities and of elective affinities in the world of forms occurs in another realm than that merely of sympathy, since sympathy always runs the risk of being either propitious or adverse. These affinities are not defined and limited by any particular moment, but develop broadly throughout the course of time. Although each individual is contemporary first of all with himself and with his generation, he is also contemporary with the spiritual group of which he is a member. This is even more the case as regards the artist, because to him his ancestors and friends are not recollection, but presence. They stand immediately before him, in full life. Herein lies the explanation of the role of museums in the nineteenth century: they assisted the various families of the mind in their work of self-definition and union, beyond all demands of time and of place. Even at certain epochs and in certain countries, where the evidence and the examples lie scattered, even when the state of styles imposes a strictly orthodox unity, even in the most demanding of social milieux, the variety of families of the mind continues to express itself with the utmost vigor. And the very period that most brusquely turns away from the past is built up by the men who have been formed by tradition. Times and environments that do not belong to history move into history itself, and races that are not the races of anthropology spread far and wide. Such races may or may not be aware of their own existence. But they do exist, and in order to exist they have no need to affirm themselves as entities. Between masters who have never had the slightest personal acquaintance, and whom everything has kept apart —

nature, distance, time — the life of forms establishes an intimate relationship. Here, then, is a new refinement on the doctrine of influences: not only is there never a question of mere passive influence, but we are not obliged to invoke influence at any cost to explain a kinship that *already* exists and that calls for no active contact. The study of these families as such is of paramount importance to us. I have sketched a few of their traits in my study of one of them, the visionaries — perhaps the easiest of them all to understand. But we have already seen that the pursuit of this investigation to its fullest extent presupposes a knowledge of yet another relationship — that which exists between form and time.

Forms in the Realm of Time

In considering the problem of forms in time, our attention is called at once to two factors: first, the opposition of doctrine to doctrine, and second, the conflicting directions of thought that are in each of us. What is the place of form in time, and how does it behave there? To what extent is form time, and to what extent is it not? Now, on the one hand, a work of art is nontemporal; its activity, its struggle occur primarily in space. And on the other hand, it takes its place in a sequence both before and after other works of art. Its formation does not occur on the spur of the moment, but results from a long series of experiments. To speak of the life of forms is inevitably to invoke the idea of *succession*.

But the very idea of succession presupposes different concepts of time. Time may be interpreted in turn as a fixed norm of measurement or as a mere general movement, as a series of immobile happenings or as a continuous mobility. Historical knowledge resolves this antinomy by means of a definite construction of time. Any inquiry into the past that does not have this construction as its object is meaningless. Such an inquiry develops according to a perspective, that is, within certain limits, and by following a strict arrangement of measures and relationships.

The organization of time for the historian rests, as does that

of our own lives, on chronology. It is not sufficient to know simply that events follow one upon the other; what is important is that they follow at stated intervals. And these intervals themselves authorize not only the classification of events, but even (with, of course, certain restrictions) the interpretation of them. The relationship between two facts in time differs according to the distance that separates them; it is somewhat analogous to the relationship of objects in space and in light, to their relative sizes and to the projection of their shadows. Points of reference in time have no numerical value, as such. They are not the divisions of the yardstick, measuring off the emptiness of any nondescript space. The day, the month and the year have a variable but nevertheless definite beginning and end. They stand as so many evidences of the authenticity of our reckoning. The historian of a world that was perpetually flooded with steady light, a world without day or night, month or season, would be able to describe only a more or less complete present. The measurement of time originates within the frame of our own lives, and the technique of history follows nature closely in this respect.

Inasmuch, then, as we are subjected to an order that is both necessary and sanctioned at all points, we may perhaps be excused for our oftentimes serious confusion between chronology and life, between points of reference and fact, between measurement and action. We are exceedingly reluctant to surrender the isochronal concept of time, for we confer upon any such equal measurements not only a metrical value that is beyond dispute, but also a kind of organic authority. These measurements presently become frames, and the frames then become bodies. We personify them. Nothing, for instance, could be more curious in this respect than our concept of the century. We find it difficult not to think of a century as a living entity, or to refuse it a likeness to man himself. Each century reveals itself to us with a color and a physiog-

nomy; each century's shadow has a clearly defined silhouette. It is, I think, an entirely defensible procedure to give configuration to these vast landscapes of time. A notable consequence of this organicism is that of making each century begin with a kind of childhood which is continued by youth, and which in its turn is replaced by maturity and then by senility. It may come to pass, by some mysterious working of our awareness of history, that this form will finally react in a concrete way. Through handling it, giving it substance and interpreting the various periods within the span of one hundred years as the various ages of man that are included between the parentheses of birth and death, humanity acquires the habit of living by centuries. This collective fiction has a powerful effect on the work of the historian. Even if we acknowledge, however, that popular usage was in a position to "realize," about the year 1900, the notion of *fin de siècle*, it is still not necessarily true that the chronological end or beginning of any century inevitably coincides with the beginning or the end of a given historical activity. Historical studies, as well, are by no means exempt from this "centurial" mysticism. To confirm this fact, one need only consult the table of contents of almost any historical work.

This particular concept has a really monumental quality: it organizes time as if it were architecture, and distributes it, like the masses of an edifice on a known plan, within stable chronological environments. This is also the "time" used in museums, that is, that allocated to rooms and exhibition cases. This concept tends, moreover, to mold historical life into distinct segments and to endow them with an active, efficient value. But, deep within ourselves, we know that time is a "becoming." With varying degrees of success, we therefore rework our monumental concept of time into that of a fluid time, or, one whose duration has a plastic quality. We cannot help but recognize a generation

139

as being a complex in which all the ages of man are mingled, or a century as being more or less than one hundred years long, or eras as merging one into the other. The fundamental element of chronology, the date, makes it possible for these overelaborate measurements to be reduced to perfect exactitude. It is the safeguard of every historian.

It must not be thought that the mysticism that colors our notion of the century does not also color our notion of the date – at least when regarded as a kind of magnetic pole, as a force in and of itself. But a single date embraces an extreme diversity of place and of action and, in one and the same place, even more diverse actions in the various realms of politics, economics, society and art. The historian who reads events in sequence also reads them in breadth, synchronously, as the musician reads a full orchestral score. History is not unilinear; it is not pure sequence. We may best regard it as the superimposition of very widely spaced present moments. From the fact that various modes of action are contemporaneous, that is, seized upon at the same moment, it does not follow that they all stand at an equal point in their development. At the same date, politics, economics and art do not occupy identical positions on their respective graphs, and the line joining them at any one given moment is more often than not a very irregular and sinuous one. In theory, we readily admit this; in practice, we give way to our need for some pre-established harmony, that is, for regarding the date as a focus, a point within which everything is concentrated. And yet, even though the date may indeed be such a point, it is not so by definition. History is, in general, a conflict among what is precocious, actual or merely delayed.

Each order of action obeys its own impulse — one that is determined by internal exigencies and retarded or accelerated by external contacts. Not only are these impulses dissimilar among

themselves, but none of them is individually uniform. The history of art displays, juxtaposed within the very same moment, survivals and anticipations, and slow, outmoded forms that are the contemporaries of bold and rapid forms. A monument that has been dated with certainty — stylistically, that is — may have come into being before or after its historical date, and this is exactly why it is important to date it first. We have short-wave and long-wave time, and the purpose of chronology is not to prove the constancy and isochronism of movements, but to measure the difference in the wavelength.

We can now account for the way in which the problem of form in time presents itself. This problem is a double one. First, it is internal: What is the position of a work of art in its formal development? Second, it is external: What is the relation of this development to other aspects of human activity? If the time of a work of art were the time of all history, and if all history progressed at the same rate, these questions would never need to be asked. But such is not the case. Instead of being a neatly plotted series of harmonic tableaux, history is, throughout its entire course, variety, exchange and conflict. Art is involved here, and, art being action, art acts both within itself and beyond itself.

According to Taine, art is a masterpiece of *external* convergence. This contention demonstrates the serious inadequacy of Taine's system — an inadequacy that is far more offensive even than the false stiffness and the purely providential character of determinism. Taine's merit lies in having been, as it were, a kind of interior decorator of time: that is, he disregarded it as a force in and of itself, even though time, like space, is nothing unless it has been really lived. It is, too, to his credit that he broke away from the myth of Time as the deity with the scythe — whether destructive or creative — and sought a common bond among all the various efforts of man, be they racial, environmental or tem-

poral. In this way, he unquestionably established a worthwhile technique, although one that is less so for the history of art than for the history of culture. It may nevertheless be questioned whether this brilliant ideologist of life, by substituting the plenitude of human culture for the bustling void of time, has done anything more than transpose mythologies.

This is not the place to enter into any protracted discussion of the old concept of race. This concept has, at the hands of ethnology, anthropology and linguistics, always been beset by a good deal of confusion. No matter from what viewpoint it may be regarded, race is not stable and it is not constant. It thins out, increases, commingles. It is modified by climate, and the mere fact that it moves at all is an indication that it changes. Both the man who sits by his fireside and the man who roams abroad are exposed at all points to these changes. Nowhere in the universe are there conservatories in which pure races may be found in flower. The most careful practice of endogamy does not prevent crossbreeding; the best-protected insular environments are open both to infiltration and to invasion. Even the constancy of anthropological indices by no means implies that values are changeless. Man works on himself. But he does not, it is true, rid himself of the age-old deposits laid down by time, and they are something that must be accounted for. What they constitute is a tonality, rather than an armature or a foundation. They introduce into the complex equilibrium of a culture inflections and accents similar to those that characterize a spoken language. Art, to be sure, sometimes lends to them a strange relief. They stand out, like great rock-faults, tokens of the past, in a landscape now at peace. It may well be said that certain artists are unusually "ethnic," but they are the exception and not the rule. For, art is made in the living world of forms and not in the indeterminate region of instincts. The fact of having torn the instinct of a work of art from

the half-light of the inner life implies a multitude of new contacts
and the dominion of new stimuli. The formal vocation comes into
play, affinities meet, the artist joins his own brotherhood. How,
even within the most homogeneous race, can the presence be
denied of a great diversity of families of the mind, all of whom
impose their system on that of the race itself? And the artist
belongs not only to a family of minds and to a race: he belongs
also to an artistic family, for he is one who works on forms, and
on whom forms work.

We here encounter, then, a limitation against which we must
be on our guard. It would be better called, perhaps, a displace-
ment of values. But has it not been maintained that in certain
realms of art, in which individual effort yields more readily to
tradition and to the collective spirit, there is displayed an unusually
close relationship between man and his ethnic group, that is, his
race, as for instance in ornament or in the popular arts? That cer-
tain formal systems are the authentic possessions of certain races?
That the interlace is the image and the symbol of a mode of
thought characteristic of northern peoples? I would answer that
the interlace, and in a more general way, the entire vocabulary
of geometry, are the common property of *all* primitive human-
ity, and when they reappear at the beginning of the high Middle
Ages, masking and distorting the anthropomorphism of the Med-
iterranean world, they by no means represent the shock of impact
between two races, but instead the meeting between two kinds
of time or, to put it more clearly, between two kinds of human
society. These encounters may take place on apparently dissimi-
lar levels, but among them all there is an underlying identity. For
example, in secluded settlements the popular arts cling to their
ancient state, to a sense of time that seems scarcely ever to move,
and to old, prehistoric vocabularies, with a unity which far sur-
passes any ethnographic and linguistic divisions. These arts are

colored by the environments, the landscapes of historical life, and by nothing else. The same critical approach may be applied, although in a different sense, to the romantic interpretation of Gothic art. In the nineteenth century, the complex, enormous, shadowy cathedrals of that art stood as the definitive expression of a "race" that until then had ignored them, and whose imitation of them was thenceforward always maladroit. The romantic interpreters — the spokesmen for this "race" — thought that they were reviving the genius of the forest, in a lovely but specious metaphor that likened a cathedral to a glade of trees. It was all a confused naturalism, jumbled up within the ardors of faith. And these ideas are still not completely dead. Each generation lends them an ephemeral life; they have the periodicity of those collective myths that so often bathe history in the light of fancy and legend. The study of forms that I am here attempting to make abolishes this secondhand poetry, and brings into being an experimental logic that gives the lie on every hand to any system so dangerously topsy-turvy.

Man is not fixed fast within a single, unalterable definition; he is open to exchange and to adjustment. The groupings to which he belongs owe less to biological fatality than to the freedom of judicious adaptation, to the ascendancy of strong personalities, to the constant work of culture. A nation, too, represents a long drawn-out experiment. It has forever before its eyes the idea of its own self; it is incessantly building itself. A nation may well be regarded as a work of art. Culture is not a reflex, but a progressive appropriation and renewal. It works as a painter works, by little strokes and touches that bit by bit enrich the image. Thus, upon the murky background of races, are drawn various portraits of man, of man's own works, of modes of life that have already resolved themselves into landscapes and interiors: in short, all that "forms" space, matter and time. National groups

tend to become families of the mind, and, because of this, they come to prefer certain forms. The various states of styles do not succeed one another, in the history of these families, with the same exact regularity. Certain peoples preserve classic measure and stability in the baroque state, and others mingle a baroque accent with classic purity.

It must therefore become immediately apparent that national schools of art are not simply convenient frames. For, among these schools and beyond them, the life of forms sets up a sort of ever-changing community. There is a Romanesque Europe, a Gothic Europe, a humanist Europe, a romantic Europe. During the springtide of what we call the Middle Ages, the West collaborates with the East. Throughout the course of history, there are many periods when men think the same forms at the same time. Influence is then but the medium of affinity; it may, indeed, be said that at such times influence in no way functions beyond affinity. In order to understand the waxing and waning of these unstable and yet intimately related factors, we would perhaps be well advised to return to the old distinction made by Saint-Simon between critical periods and organic periods, the former being those characterized by the contradictory multiplicity of experiments, and the latter by the unity and the constancy of achieved results. And yet, much that is precocious and much that is delayed subsists in every organic period — which, at bottom, is always a critical period as well.

Neither the differences among individual groups nor the contrasts among centuries and periods suffice to explain the singular movements that precipitate or decelerate the life of forms. The complexity of factors affecting any movement is considerable — so much so that reflex actions can easily occur. A curious instance of this is to be found in the study of the origins of the French flamboyant style. According to certain writers, the beginnings of

this style are to be traced to English influence during the Hundred Years War. According to others, French architecture of the thirteenth century already contained the grand principle of flamboyant art, the reverse curve. These two viewpoints are equally admissible. It is entirely correct to say that the reverse curve is implied in the design of certain ancient French forms, and that the fusion of the pointed arch and the lower lobe of a quatrefoil gives it its final and perfect outline. Although the reverse curve was latent in French art, it was in actuality held in reserve and concealed, as a principle contrary to the stability of architecture and the monumental unity of visual effect. From the second half of the thirteenth century in England, nevertheless, stylistic development narrowed steadily to the baroque; it abounded in curves and reverse cuves; it proclaimed and defined an entirely new state of architecture, albeit one that it was soon to renounce. The historical coming together of two different states, of, as it were, two different speeds, therefore gave rise in French art not to a revolution due to foreign imports, but simply to a mutation that revived certain ancient and hidden traits and, at the same moment, gave to them a new potency.

And yet, this question is not so simple as it seems. In order to understand it, a casual comparison of the states of a style with the study of modalities and the effects of their contact is altogether inadequate. Such a procedure does not settle the problem of those traits that are no longer *necessarily* synchronous. For many generations, English Gothic was faithful to the concept of mass as developed in Norman art, even while, as regards curves, it was exploring future possibilities with great rapidity, thus being at one and the same time a conservative and a precocious art.

Analogous remarks might be made concerning the tardiness of architectural evolution in Germany. During a century and a half, experiments in France were multiplying and coalescing, until the

archaic forms of Romanesque gave way to the finished forms of Gothic. During this same period, however, Ottonian art was still, on the one hand, immersed in Carolingian, and was still, on the other, impregnating Rhenish Romanesque. And this last was an art that maintained its original character even after having received the rib vault.

It was not, in this case, the genius of a race or a people that kept so tight a rein on architectural development. It was, rather, the weight of examples that were intimately linked to a political tradition – which was also form – imposed on pagan, prehistoric Germania by the creators of a modern order: a form and a program conceived as such by civilizers who instantly gave to their enterprises in a virgin land proportions little short of imperial. Germany is still inordinately obsessed with this idea of enormousness. Never has architecture collaborated more patently in the creation of a world, or helped to maintain that world more scrupulously down the centuries.

The cumbersome authority of examples and the force of a formal tradition never once relaxed their hold on any part of Germany; the work of metamorphoses was consequently curbed. But in France, along the Aisne and the Oise, amid a rusticity and a mediocrity that the grandeur of empire had little affected, the definition of the ogival style was being slowly elaborated. In comparable attempts in other localities, it came to nothing or resulted in bastard forms – wherever, at least, it was opposed by some masterpiece of the Romanesque vault. And within the royal domain of the Ile-de-France, the great freedom of experimentation hastened the growth of Gothic art, until the day when its successes filled the entire horizon and were in turn strong enough to impose a formula on more slowly moving variations.

We should not omit, while studying the relationship between stylistic development and historical development, a consideration

of the influence exerted by natural and social environments on the life of forms.

In spite of the importance of the various phenomena of transference, it seems difficult to conceive of architecture as existing outside of an environment. In its original forms, this art is closely bound to the earth; it is subject to the needs of society; it is faithful to a program. It erects its great monuments beneath a known sky and in a known climate, on a soil that furnishes particular materials and no others, on a given site, in a city that is more or less wealthy, more or less populous, more or less abundant in labor. It answers collective needs, even in the construction of private dwellings. It is geographical and sociological. Brick, stone, marble and volcanic materials are not merely elements of color: they are elements of structure. The amount of rainfall determines the steepness of the gables; it calls for the gargoyles and the gutters that are installed on the weather-faces of flying buttresses. Aridity of climate permits the substitution of terraces for steep roofs. Brilliant sunlight implies shadowy naves. Where the weather is customarily dark, a multiplicity of windows is needed. The scarcity and high cost of land in populous towns control corbeling and the overhanging of stories.

But, on the other hand, such historical environments as the great feudal states of the eleventh and twelfth centuries in France clearly help us to differentiate the various families of Romanesque churches. The combined activity of the Capetian monarchy, the episcopacy and the townspeople in the development of Gothic cathedrals shows what a decisive influence may be exercised by the alliance of social forces. And yet, no matter how powerful this activity may be, it is still by no means qualified to solve problems in pure statics, to combine relationships of values. The various masons who bonded two ribs of stone crossing at right angles beneath the north tower of Bayeux, or who inserted, under

totally different circumstances, a rib vault in the deambulatory at Morienval, or who worked with the creator of the choir at St. Denis, were geometers working on solids, and not historians interpreting time. The most attentive study of the most homogeneous milieu, of the most closely woven concatenation of circumstances, will not serve to give us the design of the towers of Laon. Exactly as mankind modifies the face of the earth and creates a sort of geography that is his alone, by means of agriculture, deforestation, canals and roads, so does the architect engender new conditions for historical, social and moral life. No one can predict what environments architecture will create. It satisfies old needs and begets new ones. It invents a world all its own.

The concept of environment, therefore, cannot be accepted crudely as such; it must be broken down, and recognized both as a variable and as a movement. Geography, topography and economics, although related, are not one and the same thing. Venice, for example, was a place of refuge, originally chosen for its inaccessibility, and it was also a place for commerce, grown prosperous because of its ease of access. Its palaces were counting houses that signified the progress of its wealth. They opened onto convenient porticoes that were docks and warehouses. Economy here complied with topography and drew advantage from it. The affluence born of trade explains the ostentation that spread, little short of insolently, across the facades of Venetian buildings; it explains as well the Arabian luxury of a city that faced both East and West. The perpetual mirage on the water and in its reflections, the crystalline particles suspended in the humidity of the air — these brought into being certain kinds of dreams and certain kinds of tastes that have been incomparably translated in the music of many poets and the warm tones of many colorists. Nowhere more perfectly than here can we hope, by the very conditions of Venice's environment and by making use of a certain ethnic mixture whose

ingredients are easily proportioned, to apprehend the temporal
genealogy of a work of art. But Venice has worked on Venice with
a most extraordinary freedom. The paradox of its construction is
its struggle *against* the elements: it has installed Roman masses
on sand and in water; it has outlined against rainy skies oriental
silhouettes that were first conceived for use in perpetual sunlight;
it has waged an unending war against the sea by devices of its own
invention — the "maritime tribunes," the works of masonry, the
murazzi — and finally, it has seen the overwhelming preference
of its painters for landscape, for the green depths of forest and
mountain that lay so close at hand in the Carnic Alps.

It may, then, so happen that a painter will deliberately break
away from his environment and select another. Having once cho-
sen it, he transforms and recreates it, he confers upon it a uni-
versal and human value. Rembrandt, at first the painter of the
solemn occasions of medicine — the study of anatomy and of dis-
section — breaks away from neat, middle-class, hypercritical
Holland, the Holland of chamber music, of polished furniture,
of tiled parlors, and steeps himself in the Bible, and in all its
magnificent squalor, its tattered bohemianism, its vivid rowdi-
ness. The ghetto of Amsterdam was, to be sure, at hand. But
Rembrandt knew that he must penetrate deeply into it and make
it his own, that he must bring to life, in the cast-off garments worn
by Portuguese Jews, all the anxiety of the Old Testament at the
moment it was begetting the New; that he must make a verita-
ble apocalypse of light blaze forth from the depths of that ghetto,
a sun grappling with shadow in dark cellars that were filled with
prophecy. Even as he stands in the very midst of this profane and
vibrant world — a world that was jealously closed off and yet
crowded with wanderers — Rembrandt places himself outside of
Holland, and outside of time. Even in the ghetto, he could, of
course, still be a painter of customs, a chronicler of a given urban

quarter. And it is exactly to these proportions that he must never be reduced. It is perfectly clear that this chosen environment interested him only because it was spacious enough for his dreams, and favored their development. There they touched ground, there they took shape. There Rembrandt's world adapted itself and found a unity that exalts but never limits. That world creates a landscape, a light and a humanity that are of course Holland, but withal a supernatural Holland.

The case of Van Dyck deserves a special analysis (Figure 20). Although it touches on the philosophy of portrait painting, it is still directly relevant to our thesis. It may well be asked whether this Prince of Wales of painting (to retain the title given him by Fromentin) did not in large measure contribute to the *creation* of a social environment, thus reversing the terms of a commonly accepted proposition. Van Dyck lives in an England that is still crude and violent, still torn by revolutions, still given over to the pleasures of the instinct and still maintaining beneath the thin varnish of court life the appetites of "Merry England." He paints its heroes and heroines with his own native distinction, even when his models are such plain and worthy folk as fat Endymion Porter. He discovers and discloses in pretty girls and in adventures of worldly gallantry that dashing look, that cavalier bravery and even that romantic melancholy which, first of all, lie wholly within himself and with which, as with some charming seal, he laid his mark upon his poets and captains. Here it is that the brilliant flower of his painting comes into play — that precious material, fine and fluid, those shimmering, musical notes that compose one of the most delicate luxuries ever made for our eyes. Here he holds up to English snobbishness the mirror in which henceforth, for generations, through all the changes of taste, it complacently views itself. Even today those who sit for a fashionable painter unconsciously wish to resemble the portraits of long ago,

and behind these admirable figures of modern English gentlemen one seems to divine the invisible presence of their secret arbiter – Van Dyck himself.

Race and environment are not in suspension beyond and outside of time. Both are time that has been lived and formed, and this is why both are properly historical conditions. Race is a development, subjected to irregularities, mutations and exchanges. The geographical environment itself, standing as it does on apparently unshakable foundations, is still susceptible of modification. So too does the disparate activity of social environments exist within time. This is why the *moment* must inevitably be brought into play. What exactly is the moment? I have pointed out that historical time is sequential, but that it is not pure sequence. The moment is not simply any point along a line; it is rather a node, a protuberance. Nor is it the sum total of the past, but instead the meeting point of several forms of the present. Is there, however, any *necessary* accord among the moment of the race, the moment of environment and the moment of life? Perhaps the inherent character of a work of art is to ensnare, to give representation to and, in a certain measure, to provoke that accord. At first glance it would seem that we are here touching on the very essence of the relationship between art and history. If so, art would appear to be a most remarkable series of purely chronological happenings, similar to the transposition into space of a whole gamut of far-reaching actualities. But this point of view is as superficial as it is seductive. A work of art is something that is both actual and non-actual. Race, environment and moment are not naturally and constantly favorable to any given family of minds. The spiritual instant that is our life does not necessarily coincide with a historical urgency; it may indeed even contradict it. We have no right to confuse the state of the life of forms with the state of social life. The time that gives support to a work

Figure 20. Van Dyck: Portrait of a Lady, Called the Marchesa Durazzo.

of art does not give definition either to its principle or to its specific form. It is quite capable of slipping back into the past or forward into the future. The artist inhabits a country in time that is by no means necessarily the history of his own time. He may, as I have said, be thoroughly contemporary with his age and may even, because of this fact, adapt himself to the artistic activities going on around him. With equal consistency he may select examples and models from the past, and create from them a new and complete environment. He may, again, outline a future that simultaneously strikes into the present and the past. But a sudden shift in the equilibrium of his ethnic values may bring him into violent opposition with his environment and hence with the moment, and arouse a nostalgia in him that is highly revolutionary. He then seeks the world that he needs. There do exist, to be sure, men of genius who are, at least outwardly, temperate and facile, and who are supported by what a certain determinism calls happy circumstances. But these great lives whose surfaces seem so smooth nevertheless conceal great conflicts. The history of form in Raphael — whose life we have come to look on as a model of perfect happiness — reveals serious crises. His time held out to him the most diverse images, the most flagrant contradictions. And, deep within himself, he gave way again and again to a ductility of instinct and a lack of resolution that remained with him until at long last he boldly inserted into his age a new time and a new environment.

This special power is even more striking when we reflect on the fact that the moment of a work of art is not necessarily the moment of taste. It may freely be admitted that the history of taste faithfully reflects sociological conditions, providing we introduce those imponderables, such as the altogether fantastic element of fashion, that modify whatever they touch. Taste may qualify the secondary characteristics of certain works of art —

their tone, their look, their external rules. And certain works of art qualify taste and mark it deeply. This accordance with the moment, or better, this creation of the moment, is sometimes immediate and spontaneous, sometimes sluggish and intractable. One is tempted to conclude that, in the former case, a work of art suddenly and with great power promulgates a necessary actuality that had long been seeking with feeble, rudimentary movements to define itself, and that, in the latter case, a work of art eventually overtakes its own actuality and forestalls the moment of taste. But in both cases, a work of art is, at the very instant of its birth, a phenomenon of *rupture*. This is vividly brought home by a current expression: *faire date*. It is not a question of breaking quietly in on chronology, but of bursting suddenly in on the moment.

To the concept of the moment, therefore, we should add that of the event. The latter both corrects and completes the former. What actually is the "event"? It is, as I have just said, a highly efficient abruptness. This abruptness may be relative or absolute; it may be contact with or contrast between two unequal developments; it may be merely a change arising from within one of these developments. A form can assume a new and revolutionary character without being an event in and of itself; it can also assume this character from the simple fact of being transported from a rapidly moving environment into a slowly moving one, or inversely. But a form can most distinctly be a formal event without at the same time being a historical event. We may in this wise be led to observe a sort of mobile structure of time that displays, in accordance with the diversity of movement, many different kinds of relationships. Several examples and, perhaps, several broad general rules have already been observed regarding the structure of space, of matter and of spirit, as we undertook the study of their forms. To this structure that of time is, in its

155

leading principles, analogous. If a work of art creates formal environments that impose themselves on any definition of human environments; if families of the mind have a historical and psychological reality that is fully as manifest as is that in linguistic and ethnic groups, then a work of art is an event. It is, in other words, a structure, a defining of time. All these families, environments and events that are called forth by the life of forms act in their turn on the life of forms itself, as well as on strictly historical life. There they collaborate with moments of civilization, with both natural and social environments, and with human races. This immense multiplicity of factors is in complete opposition to the harshness of determinism, into which, by breaking it down into endless action and reaction, it introduces cleavage and discord at every turn.

For, within this great imaginary world of forms, stand on the one hand the artist and on the other hand form itself. Even as the artist fulfills his function of geometrician and mechanic, of physicist and chemist, of psychologist and historian, so does form, guided by the play and interplay of metamorphoses, go forever forward, by its own necessity, toward its own liberty.

In Praise of Hands

I undertake this essay in praise of hands as if in fulfillment of a duty to a friend. Even as I begin to write, I see my own hands calling out to my mind and inciting it. Here, facing me, are these tireless companions who for so many years have served me well, one holding the paper steady, the other peopling the white page with hurried, dark, active little marks. Through his hands man establishes contact with the austerity of thought. They quarry its rough mass. Upon it they impose form, outline and, in the very act of writing, style.

Hands are almost living beings. Only servants? Possibly. Servants, then, endowed with a vigorous free spirit, with a physiognomy. Eyeless and voiceless faces that nonetheless see and speak. Some blind persons eventually acquire a touch so sensitive that they can identify playing cards by the infinitesimal thickness of the shapes printed on them. But those who can see also need their hands to see with, to complete the perception of appearances by touching and holding. The aptitudes of hands are written in their curves and structure. There are tapered slender hands, expert in analysis, with the long and mobile fingers of the logician; prophetic fluid hands; spiritual hands whose very inactivity has grace and character; and tender hands. Physiognomy, once diligently

practiced by those who were expert in it, would have benefited by a knowledge of hands. The human face is above all a composite of the receptive organs. The hand means action: it grasps, it creates, at times it would seem even to think. In repose, the hand is not a soulless tool lying on the table or hanging beside the body. Habit, instinct and the will to action all are stored in it, and no long practice is needed to learn what gesture it is about to make.

All great artists have paid close attention to the study of hands. Since more than other men they live by their hands, they have sensed the peculiar power that lies in them. Rembrandt shows hands to us in all the varied emotions, types, ages and conditions of life (Figure 21): the gaping astonished hand, thrust in shadow against the light, of a witness in the large *Raising of Lazarus*; the workmanlike and scholarly hand of Professor Tulp holding with a clamp a bundle of arteries in the *Anatomy Lesson*; the hand of Rembrandt himself in the act of drawing; the powerful hand of Saint Matthew writing at the angel's dictation; the hands of the aged paralytic in the *Hundred Guilder Print*, bent double by the coarse, inert mittens hanging at his waist. It is true that certain masters have painted hands by shop rule and with an unvarying sameness, and that this is an anthropometric index useful for the critic's classifications. Yet how many pages of drawings reveal an analytic concern for catching what is unique! Even by themselves, such hands are intensely alive.

What gives the hand this advantage? Why does this mute, blind organ speak to us so persuasively? Because it is, like the higher forms of life, highly original and highly differentiated. Jointed on its delicate hinges, the wrist has a structure of many small bones. From it five skeletal branches, each with its system of nerves and ligaments, run beneath the skin, thence they fan out into five separate fingers. Each of them, articulated on three knuckles, has its own aptitude and its own mind. A curved sur-

Figure 21A. Rembrandt: Detail from The Raising of Lazarus.

Figure 21B. Rembrandt: Detail from The Anatomy Lesson of Dr. Nicolaes Tulp.

face traced with veins and arteries, and rounded at the edges, links the wrist with the fingers, masking their hidden structure. The underside forms a receptacle. When the hand is active, it can stretch and stiffen. Quite as easily it can shape itself around an object. This activity has left marks in the hollow of the hand, and one can read there, if not the linear symbols of things past and things to come, at least the pattern and as it were the memories of our lives otherwise lost to us, and perhaps as well some even more distant inheritance. Observed closely, the palm is indeed a strange landscape with its hills, its main central depression, its narrow tributary valleys, now crinkled with incidental lines, links and interlaces, now clean and sharp like handwriting. Each configuration can evoke a daydream — I do not know whether anyone who earnestly consults his hand will be able to solve an enigma, but I like to think that he will study this proud servant of his with respect.

Watch your hands as they live their own free life. Forget for a moment their function, forget their mystery. Watch them in repose; the fingers are lightly drawn in, as if the hands were absorbed in a reverie. Watch them in the sprightly elegance of pure and useless gestures, when it seems that they are describing numberless possibilities gratuitously in the air and, playing with one another, preparing for some happy event to come. Although they can imitate the silhouettes and the behavior of animals by casting their shadow on a wall by candlelight, they are much more beautiful when they imitate nothing at all. Sometimes, left to themselves when the mind is active, they move ever so faintly. On an impulse they stir the air, or they stretch their tendons and crack their knuckles, or else they close tightly to form a compact mass that is truly a rock of bone. Sometimes it happens that, first raised, then lowered, one after the other in invented rhythms, the fingers trace, nimble as dancers, choreographic bouquets.

The hands are not a pair of passively identical twins. Nor are they to be distinguished like younger and older children, or like two girls with unequal talents, one trained in all skills, the other a serf dulled by the monotony of hard work. I do not believe altogether in the eminent dignity of the right hand. Deprived of the left, it withdraws into a painful, almost sterile solitude. The left hand, which signifies unjustly the evil side of life, the "sinister" portion of space, the side from which one must not come upon a corpse or enemy, or a bird — the left hand can be made to perform all the duties of the right. Fashioned like it, it has the same aptitudes, which it renounces in order to assist its partner. Does it clasp any less vigorously the tree trunk or the handle of an axe? Does it clutch an adversary's body with less force? Has it less power when it strikes? Does not the left hand form the notes on a violin, attacking the strings directly, while the right hand merely projects the melody with the bow? We are fortunate in not having two right hands. How else would the diversity of tasks be apportioned? Whatever is "gauche" about the left hand is indispensable to an advanced culture; it keeps us in touch with man's venerable past, with a time when he was not over-skillful, and still far removed from being able to create; with a time when he was, as the popular phrase goes, "all thumbs." Had it been otherwise, we should have been overwhelmed by too much virtuosity. No doubt we should have forced the juggler's art to its farthest limits — and probably have accomplished little else.

Such as it is, this pair of hands has not only served man's purposes, but has helped to create them, define them and give them form and shape. Man has created his own hands — by which I mean that he has gradually freed them from the animal world, released them from an ancient and innate servitude. But hands have also created man. They have permitted him certain contacts with the world which his other organs and the other parts of his

body could not vouchsafe. Held against the wind, spread out and separated like a frond, they urged him on to an understanding of fluids. They provided him with numerous and delicately sensitive surfaces for his knowledge of atmosphere and of water. Pollaiuolo, a master in whom a somewhat troubled and wild sense of the mysteries of Fable persists with considerable grace under a very thin veneer of humanism — Pollaiuolo painted a pretty Daphne overtaken by metamorphosis at the very moment Apollo is about to reach her. Her arms are becoming tree limbs; already the extremities are leafy branches stirred by gentle breezes. I seem to see primitive man inhaling the world through his hands, stretching his fingers into a web to catch the imponderable. "My hands," said the Centaur, "have felt rocks, waters, plants without number and the subtlest impressions of atmosphere, for I lift up my hands on dark, still nights to detect the breezes and so discover signs to make sure of my way." The Centaur and Daphne, both favorites of the gods, had, in metamorphosis or not, no weapons other than those of our race to feel out the universe, to experience even those translucent currents which have no substance and which the eye does not see.

Yet, whatever weighs upon us with a vague heaviness or with the warm palpitation of life, whatever has a bark, a covering, a fur or even stone, though it be shaped by blows or rounded by the flow of waters or left intact in texture — all these things are but occasions for the work of hands. They are the goal of an experiment that neither sight nor mind can conduct alone. Knowledge of the world demands a kind of tactile flair. Sight slips over the surface of the universe. The hand knows that an object has physical bulk, that it is smooth or rough, that it is not soldered to heaven or earth from which it appears to be inseparable. The hand's action defines the cavity of space and the fullness of the objects that occupy it. Surface, volume, density and weight are not optical

phenomena. Man first learned about them between his fingers and in the hollow of his palm. He does not measure space with his eyes, but with his hands and feet. The sense of touch fills nature with mysterious forces. Without it, nature is like the pleasant landscapes of the magic lantern, slight, flat and chimerical.

Thus did gestures multiply man's knowledge with a variety of touch and contour whose inventive power is now hidden to us by centuries of practice. Without hands there is no geometry, for we need straight lines and circles to speculate on the properties of extension. Before he could recognize pyramids, cones and spirals in shells and crystals, was it not essential that man should first "play with" regular forms in the air and on the sand? Man's hands set before his eyes the evidence of variable numbers, greater or smaller, according to the folding and unfolding of his fingers. For a long time the art of calculation had no other formula; and it was by this method that the Ishmaelites sold Joseph to Pharaoh's men, an episode shown in the Romanesque fresco of St. Savin, where the eloquence of the hands is extraordinary. Language, first experienced by the whole body and mimed in the dance, was also formed by the hands. In everyday use, movements of the hands gave zest to the language, helped articulate it, separate its elements, isolate them from a vast sonorous syncretism and helped to give rhythm to language, even to color it with subtle inflections. From this mimicking of the spoken word, from these exchanges between voice and hands, some trace remains in what the ancients called oratorical gesture. Physiological differentiation has further specialized our organs and functions, which scarcely collaborate any more. Speaking with our mouths, we remain silent with our hands, and in some parts of the world it is bad taste to express oneself both by voice and gesture. Elsewhere, however, this dual and poetic manner of expression has been preserved with the most affectionate ardor. Even when its

effects are a little vulgar, it expresses accurately an early state of man, the memory of his efforts to invent a new language. There is no need to choose between the two formulae over which Faust hesitates: in the beginning was the Word, in the beginning was Action; because Action and the Word, the hands and the voice, are united in the same beginnings.

The power to create a concrete universe distinct from nature is, however, the kingly gift of the human race. The industry wrought by a beast without hands, even though he be among the highest products of evolution, is dull and monotonous and remains at the threshold of art. He can build for himself neither a magical world nor even a useless one. He can mimic a religion of his own species by a love dance, or even suggest certain funerary rites; but he could never "charm" by the power of images nor produce disinterested forms. But what of the bird? Its most delightful song is only an arabesque around which we compose a symphony of our own, as we do with the murmur of the waves or the wind. Perhaps confused dreams of beauty stir sumptuously adorned beasts; perhaps they are dimly conscious of the magnificence of their own dress. Certain nameless relationships which we cannot decipher may even explain a superior harmony in the magnetic field of animal instincts. These waves of attraction escape our senses, but nothing prevents us from thinking that their coincidence resounds strikingly and profoundly in the life of insects and of birds. Such music is shrouded in total mystery. Even the most surprising accounts of beavers, ants and bees demonstrate the limits of cultures that have for equipment only paws, antennae and mandibles. But man, taking into his hands a few shreds of the world, has been able to contrive another world that is altogether his own.

As soon as man tries to intervene in the natural order to which he is subject, from the moment he begins to push a pointed

instrument or a sharp edge into some hard material in order to split it and give it form, his primitive labor contains in itself its whole future development. The caveman carefully chipping the flint and fashioning needles out of bone astonishes me much more than the clever builder of machines. He is no longer activated by unknown forces; he can work on his own. Formerly, even in the recesses of the deepest cave, he remained on the surface of things; even when he broke up animal vertebrae or tree limbs, he did not penetrate, he had no access to their meaning. The implement itself is no less remarkable than the use to which it is put. It is both a value and a result in itself. There it is, set off from the rest of the world, something new. Though a stone knife may have a cutting edge no sharper than that of a thin shell, it was not picked up by chance on some beach. It can be called the work of a new god, the product, indeed the extension, of his hands. Between hand and implement begins an association that will endure forever. One communicates to the other its living warmth, and continually affects it. The new implement is never "finished." A harmony must be established between it and the fingers that hold it, an accord born of gradual possession, of delicate and complicated gestures, of reciprocal habits and even of a certain wear and tear. Now the inert instrument comes alive. To this association no material lends itself better than wood, which, even when mutilated by and shaped to the arts of man, maintains in another form the original suppleness and flexibility that characterized it when growing in the forest. One might even say that the hardness of stone and iron, when repeatedly touched and handled, becomes warm and pliable. Thus, we should correct the rule of classification, which tends to standardize, and which has influenced toolmaking from earliest times because the amount of exchange was facilitated by the constancy in the types produced. Contact and usage humanized the inert object and more or less set it apart

from its classification as something unique. Anyone who has not known men who live by their hands cannot understand the strength of these hidden relationships, the positive effects of this association in which are found friendship, respect, the daily communion of work, the instinct and pride of ownership and, on the highest plane, the concern for experimentation. I do not know whether there is a break between the manual and the mechanical orders — I am not very sure of it — but the implement at the end of his arm does not refute man's existence. It is not like an iron hook screwed into a stump. Between them comes that god in five persons who runs the gamut of all dimensions, from the hand of the cathedral mason to the hand of the painter of manuscripts.

Though in one of his aspects the artist is perhaps the most highly evolved of all types, prehistoric man nonetheless continues to persist in him. To the artist, the world is ever fresh and new. He examines it, he enjoys it with senses sharper than those of a civilized man, and he keeps alive the sense of magic in the unknown and, above all, the sense that his hands are instruments both of poetry and of industry. Whatever the receptive and inventive powers of the mind may be, they produce only internal chaos if deprived of the hand's assistance. The dreamer may entertain visions of unimaginable landscapes and of ideally beautiful faces, but he has no means for fixing fast these tenuous, insubstantial visions; and memory hardly retains them, except as the recollection of a recollection. What distinguishes dream from reality is that the dreamer cannot engender art, for his hands are asleep. Art is made by the hands. They are the instrument of creation, but even before that they are an organ of knowledge. I have shown how this is so for everyone; for the artist it is even truer, and in very particular ways. The artist must live all the primitive experiments over again; like the Centaur he must feel out the wellsprings and the winds. While our contact is a passive one, his is

something sought after and worked over. We are content with an age-old acquisition, with an automatic, perhaps worn-out knowledge buried inside ourselves. This the artist exposes to fresh air and brings to life again; he starts from the very beginning. Is it not more or less the same with a child? Adult man, however, loses this attitude of trial and error, and because he has grown up, he stops growing. The artist prolongs the child's curiosity far beyond the limits of childhood. He touches, he feels, he reckons weight, he measures space, he molds the fluidity of atmosphere to prefigure form in it, he caresses the skin of all things. With the language of Touch he composes the language of Sight — a "warm" tone, a "cool" tone, a "heavy" tone, a "hollow" tone, a "hard" line, a "soft" line. But the language of speech is not so rich as the impressions conveyed by the hands, and we need more than one language to translate their quantity, their diversity and their fullness. We must therefore somewhat extend the idea of "tactile value" as it was formulated by Bernard Berenson. In painting it is not simply a matter of achieving the living illusion of relief and volume by inviting us to exercise our muscles in mimicry of the painted movement through inner impulse — with whatever is suggested of substance, weight and animation. For touch is at the very beginning of Creation. Adam was molded of clay, like a statue. In Romanesque iconography, God does not breathe on the globe of the world to send it off into the ether. He sets it in place by laying his hand upon it. And the hand that Rodin used to represent the six days of creation is, as it starts up from the block in which the forces of chaos lie dormant, a most formidable one. What is the meaning of the myth of Amphion, who by the song of his lyre moved stones so potently that they rolled themselves to Thebes of their own accord to construct its walls? Doubtless it means nothing more than the ease of working to a proper musical accompaniment, especially with men who use their hands,

like the oarsmen of ancient galleys, their stroke sustained and cadenced by the air of a flute. We know even the name of the man who strove hardest in building the walls of Thebes. He was Zethos, brother of the lyre player. Zethos is seldom spoken of. Perhaps a time will come when a melodic phrase will be enough to make the flowers bloom, and whole sceneries unfold. But suspended in empty space as if on the screen of a dream, will they have any more substance than the image in a dream? The myth of Amphion, which originated in the land of marble cutters and bronze founders, would disconcert me if I did not remember that Thebes never shone as a great center of sculpture. Perhaps this myth is a compensation, a consolation invented by some musician. But we woodcutters, modelers, masons, painters of the shape of man and the face of the earth, we still retain a wholesome respect for the noble weightiness of matter. For us it is the hand, not the voice or song, that struggles in emulation with it.

Did not the hand, moreover, set number in order, being a number itself and thus an instrument for counting and a master of rhythm? Above all, the hand touches the world itself, feels it, lays hold of it and transforms it. The hand contrives astonishing adventures in matter. It not only grasps what exists, but it has to work in what does not exist; it adds yet another realm to the realms of nature. For long ages the hand was content to set up unpolished tree trunks, still adorned with their bark, to bear the roof of a house or a temple. For long ages it piled unhewn boulders one upon the other to commemorate the dead and to honor the gods. Using vegetable juices to brighten the monotony of such objects, the hand deferred once again to Earth's gifts. Yet, from the day it first stripped the tree of its rugged mantle to reveal the body beneath, from the day it polished the surfaces until they became smooth and perfect, on that day the hand invented an epidermis agreeable both to look upon and to touch. The grain, once

destined to remain deeply covered, now presented mysterious for-
mations to the light. When the shapeless masses of marble bur-
ied in the mountain wildernesses were cut into blocks, slabs and
effigies of man, they seemed to change both in essence and in
substance, as if the new shape they received transformed them
to the very depths of their inanimate being, even to all their ele-
mental particles. The same for minerals extracted from their ore,
alloyed, amalgamated, fused to form unknown combinations of
metals. The same also with clay, hardened in fire and gleaming
with enameled surfaces. From the fluid and obscure dust that we
call sand, fire extracted a solid transparency. Art begins with trans-
mutation and continues with metamorphosis. It is not man's lan-
guage for communicating with God; it is the perpetual renewal
of Creation. Art is the invention of materials as well as the inven-
tion of forms. It develops its own physical laws and its own min-
eralogy. It plunges its hands into the entrails of things to shape
them to its own pleasure. First of all, art is both artisan and alche-
mist. It works in a leather apron, like a smith. Its hands are black
and torn in the struggle of contending with things that weigh and
burn. In both the shrewd and the violent actions of his mind, man
is preceded by his powerful hands.

The artist, carving wood, hammering metal, kneading clay,
chiseling a block of stone, keeps alive for us man's own dim past,
something without which we could not exist. Is it not admira-
ble to find living among us in the machine age this determined
survivor of the "hand age"? Centuries have passed over man with-
out changing his inner life, without making him renounce his old
ways of discovering and creating the world. For him, nature con-
tinues to be a repository of secrets and marvels. Always with his
bare hands — frail weapons — he seeks to carry them off in order
to make them serve him. Thus, a potent yesterday perpetually
renews itself; thus, the discovery of fire, the axe, the cart wheel

and the potter's wheel all constantly recur, but without repetition. In the artist's studio are to be found the hand's trials, experiments and divinations, the age-old memories of the human race which has not forgotten the privilege of working with its hands.

Is not Gauguin an example of those ancients who live among us, dress like us, and speak our own language? When we read about the life of the man whom I once called the Peruvian bourgeois, we first discover a bold and clever stockbroker, punctual, contented, enclosed by his Danish wife in a comfortable existence, looking at other people's paintings more with pleasure than with any personal concern. Very gradually, perhaps in response to one of those mutations that spring from the depths and split apart the surface of time, he grows disgusted with the abstractions of money and figures. It is not enough for him to plot the curves of chance with the mere resources of his mind, to speculate on the graphs of the Exchange, to play with the void of numbers. He has to paint, because painting is one way, among others, of reconquering that eternal antiquity, at once far-off and urgent, which possesses and yet escapes him. Not only painting, but all sorts of hand work draw him, as if he were avenging the long inactivity of his own hands which civilization had enforced. He works in pottery, in sculpture and even in the decoration of fabrics. Through his hands, destiny draws him toward wild and savage regions, to Brittany and to Oceania, where the immobile strata of the centuries still endure. He was not content with painting man and woman, vegetation and the four elements. He adorned himself like the savage who decorates his noble body and wears on his person the luxuriance of his art. When Gauguin was in the Islands — and he always sought out the remotest and most primitive of all — he carved idols in tree trunks, not like the copyist of an ethnographic expedition, but with an authentic hand finding out the lost secrets again (Figure 22). He built a carved hut and

Figure 22. Gauguin: Eve and the Serpent.

filled it with gods. The very materials he used, pirogue wood, the coarse and knotty cloth on which he painted as if he were using vegetable dyes and earth colors of rich low tone, these also linked him with the past, plunging him into the golden shadows of a time that has no end. This man of subtle sensibility combats that very subtlety in order to restore to the arts an intensity long submerged in too much refinement. At the same time, his right hand forgets all its skill, to learn from the left an innocence that never outstrips form. For the left hand, less "broken in" than the other, not so expert in automatic virtuosities, travels slowly and respectfully along the contours of objects. With a religious charm blending the sensual and the spiritual, the lost song of the primitive man now breaks forth.

All men, however, are not like Gauguin. Some do not take their stand on beaches, grasping a stone tool or some divinity carved from hard wood. Gauguin himself is both at the beginning of the world and at the end of a civilization. The others stay among us, even when a noble impulsion turns them into fierce prisoners, like Degas, in some lonely part of Paris. But whether they stand aloof or seek the society of men, Jansenists and sensualists alike are fundamentally beings supplied with hands; and thoughtful minds will never cease to marvel at this fact. The most delicate harmonies, evoking the secret springs of our imagination and sensibility, take form by the hand's action as it works with matter; they become inscribed in space, and they take possession of us. The imprint of this manual process is profoundly marked, even when it covers its own tracks, according to Whistler, to push the finished work back into transcendental worlds by eliminating every evidence of the artist's headlong and feverish attack. "Give me a square inch of painting," Gustave Moreau used to say, "and I will know whether it is the work of a true painter." Even the most moderated and uniform execution betrays the artist's

touch — that decisive contact between man and object, that grasping of the world we believe we can see emerging gently or impetuously under our very eyes. His touch never deceives us, whether it be in bronze, in clay, even in stone, in wood or in the plastic and fluid texture of painting. It enlivens the surfaces even of infinitely small-scale work, paradoxical as it may seem, in the old masters whose substances are polished like agate. The followers of David, who presumed to dictate their work to docile assistants, could not censor absolutely all these individual personalities. These pumiced skins, these marble-like draperies, these chill architectures, all taken in the bleak season of doctrinaire idealism — these betray variations under apparent bareness. An art from which these variations were completely banished would be a triumph of inhumanity. Let him try who will.

A young painter shows me a small, well-ordered, perhaps over-arranged landscape that, despite its diminutive size, is not lacking in grandeur. "Isn't it true that you don't find my hand any more in this work?" he says. I gather that his taste is for stable things under a changeless sky in a timeless continuum, and that he wishes to avoid all "manner," that is, all manual virtuosity in baroque fancies, in tactile gracenotes, in spattering of impasto. I understand his austere desire to eliminate his own personality and to plunge with all modesty into a great contemplative wisdom, an ascetic frugality. I admire this severe prim youthfulness, this truly French renunciation. He must not try to please or be prodigal with things charming to the sight; he must grow hard in order to endure; he must use the strong accents of intelligibility. Nevertheless, the artist's hand is felt even in the effort that it makes to be docile, in its very circumspection and modesty. It bears down on the ground, it circles around the tops of trees, it skims lightly across the sky. The artist's eye, which has followed the shapes of things and has judged their relative density, performed

the same gesture as his hand. Thus it was with the walls on which are spread, peacefully, the old frescoes of Italy. It is still the same, for whatever it is worth, even in our modern geometrical reconstructions of the universe, in those compositions which contain no recognizable objects but which combine objects broken apart. Sometimes, as if inadvertently, so great is the hand's domination even in servitude, that it gives our senses the tonic note, and we are rewarded by discovering man once more in the arid magnificence of a desert. When one realizes that the quality of a tone or of a value depends not only on the way in which it is made, but also on the way in which it is set down, then one understands that the god in five persons manifests himself everywhere. Such will be the future of the hand, until the day when artists paint by machine, as with an airbrush. Then at last the cruel inertia of the photograph will be attained by a handless eye, repelling our sympathy even while attracting it, a marvel of light, but a passive monster. Photography is like the art of another planet, where music might be a mere graph of sonorities, and ideas might be exchanged without words, by wavelengths. Even when the photograph represents crowds of people, it is the image of solitude, because the hand never intervenes to spread over it the warmth and flow of human life.

Let us go to the opposite extreme and think of works of art which above all breathe life and action. Let us consider drawings, which give us the joyful sense of fullness with the greatest economy of means – little substance, almost imponderable. None of the resources of underpainting are here, no glazes or impasto, none of the rich variations of brushwork that give brilliance, depth and movement to painting. A line, a spot on the emptiness of a white sheet flooded by light; no yielding to technical artifice, no dawdling over a complicated alchemy. One might say that spirit is speaking to spirit. And yet, the full weight of the human

being is here in all its impulsive vivacity, and with it is the magic
power of the hand that henceforth nothing can impede or delay
even when it proceeds slowly in anxious study. The hand finds
every instrument useful for writing down its signs. It fashions
strange and hazardous ones; it borrows them from nature – a twig,
a bird's feather. Hokusai drew with the end of an egg, and even
with his fingertip, ceaselessly seeking novel diversities of form
and new varieties of life. How could one ever tire of contemplat-
ing his albums and those of his contemporaries, which I should
willingly call the *Diary of a Human Hand*? You can see the hand
move about in them, nervous and rapid, with a surprising econ-
omy of gesture. The violent mark it deposits on this delicate sub-
stance, this paper made of scraps of silk, so fragile in appearance
and yet almost indestructible – dots, blots, accents and those long
crisp lines that so well express the curvature of a plant or of a
body, those brusque and crushing strokes in which the very depths
of shadow are looming – all convey to us the world's delights and
something not of this world but of man himself: a manual sorcery
not to be compared to anything else. The hand seems to gambol
in utter freedom and to delight in its own skill. With unheard-of
assurance it exploits the resources of an age-old science; but it
exploits also an unpredictable element beyond the realm of spirit,
that is to say, accident.

Many years ago when I was studying the painting of Asia, I con-
sidered writing an essay on accident, which I shall doubtless never
compose. The old story of the Greek artist who threw a sponge
loaded with color at the head of a painted horse whose lather he
despaired of rendering, is full of meaning. It not only teaches us
that in spite of ourselves everything can be saved at the very
moment when all seems lost, but it also makes us reflect on the
resources of pure chance. Here, we are at the antipodes of autom-
atism and mechanism, and no less distant from the cunning ways

of reason. In the action of a machine in which everything is repeated and predetermined, accident is an abrupt negation. In the hand of Hokusai, accident is an unknown form of life, the meeting of obscure forces and clairvoyant design (Figure 23). Sometimes one might say that he has provoked accident with an impatient finger in order to see what it would do. That is because Hokusai belongs to a country where, far from concealing the cracks in a broken pot by deceptive restoration, artisans underline this elegant tracery with a network of gold. Thus does the artist gratefully receive what chance gives him and place it respectfully in evidence. It is the gift of a god and the gift of chance latent in his own handiwork. He speedily lays hold of it to fashion from it some new dream. He is a prestidigitator (I like this long, old word) who takes advantage of his own errors and of his faulty strokes to perform tricks with them; he never has more grace than when he makes a virtue out of his own clumsiness. This excess of ink flowing capriciously in thin black rivulets, this insect's promenade across a brand-new sketch, this line deflected by a sudden jar, this drop of water diluting a contour — all these are the sudden invasion of the unexpected in a world where it has a right to its proper place, and where everything seems to be busy welcoming it. For it must be captured on the fly if all its hidden power is to be extracted. Woe to the slow gesture, and to stiff fingers! The involuntary blot with its enigmatic grimace enters, however, into the world of free will. It is a meteor, a root twisted by time; its inhuman countenance fixes the decisive note where it had to be, and where it was not sought for.

Nevertheless, a story, doubtless true in the life of such a man, tells us how Hokusai tried to paint without the use of his hands. It is said that one day, having unrolled his scroll of paper on the floor before the Shogun, he poured over it a pot of blue paint; then, dipping the claws of a rooster in a pot of red paint, he

Figure 23. Hokusai: Three Views of the Tama River.

made the bird run across the scroll and leave its tracks on it. Everyone present recognized in them the waters of the stream called Tatsouta carrying along maple leaves reddened by autumn. A charming piece of sorcery, in which nature seems to work unaccompanied to reproduce nature. The spreading blue color flows into divided streams like a real wave, and the bird's claw, with its separate and united elements, is like the structure of a leaf. Its nearly weightless trace makes accents unequaled in force and purity; and its path respects, but with the nuances of life, the intervals setting apart the delicate flotsam that the rapid water sweeps along. Can any hand translate the regular and the irregular, the accidental and the logical in this procession of things almost without body, but not without form, on the surface of a mountain stream? Very much so: the hand of Hokusai. For the memory of long experiment with his hands on the different ways of evoking life brought him, magician as he was, to attempt even this. The hands are present without showing themselves, and, though touching nothing, they order everything.

Such concord between accident, study and dexterity is often found in masters who have kept their sense of daring and the art of discerning what is unusual in the most commonplace appearances. The spiritual family of visionary artists offers us a great many examples of this. At first one imagines that they are carried away by their visions suddenly, utterly and despotically, and that they transfer them intact to any medium whatever by a hand guided from within, like those automatic artists who can draw in reverse. Nothing is less certain, however, if one examines one of the greatest of these visionaries, Victor Hugo. No mind is richer in inner spectacles, in flamboyant contrasts, in verbal surprises that depict the object with an enthralling exactness. One would willingly believe, as he did, that he was inspired like a magician and possessed by presences impatient to become appa-

ritions, complete and already three dimensional in a world at once solid and convulsive. Nonetheless, here is the very type of a man with hands, who makes use of them, not to effect miraculous cures nor to call into being the waves of the sea, but to attack matter and work in it. Hugo carries the passion for this to the very heart of some of those strange novels of his, for example in *The Toilers of the Sea*, where, with all the poetry of the struggle against elemental forces, there breathes an insatiable curiosity as to how things are made, how implements are handled, as to their possibilities, their behavior and even their archaic and disconcerting names. It is a book written by the hand of a sailor, a carpenter and a blacksmith, a hand that has a rough hold on the form of an object and models it by taking its very shape. In this novel, everything has material substance, even the waves and the wind. And it is because Hugo's remarkable sensibility has struggled with the hardness of things, with the evil waywardness of inertia, that it is so responsive to the epic character of water, and to the dramas of light, and has painted them with an almost massive power. The same man, in exile at Guernsey, made furniture and picture frames for himself, built wooden chests and, not content to set down his visions in his verses, poured off the overabundance of them in his astonishing drawings.

One may well ask whether works of this sort, which stand at the limits of some internal strife, are not at the same time a point of departure. Such minds require landmarks. To interpret the configuration of the future, a fortune-teller must seek its first lineaments in dim stains and meanders deposited by dregs in the bottom of a cup. As accident defines its own shape in the chances of matter, and as the hand exploits this disaster, the mind in its own turn awakens. This reordering of a chaotic world achieves its most surprising effects in media apparently unsuited to art, in improvised implements, debris and rubbish whose deteriora-

tion and breakage offer curious possibilities. The broken pen that spits out ink, the shredded stick, the rumpled paintbrush, are all struggling in troubled worlds; the sponge sets free moist passages of light, and granulations of the wash sparkle where it is spread. Such an alchemy does not, as is commonly supposed, merely develop the stereotyped form of an inner vision; it constructs the vision itself, gives it body and enlarges its perspectives. The hand is not the mind's docile slave. It searches and experiments for its master's benefit; it has all sorts of adventures; it tries its chance.

At this very point, a visionary like Hugo parts company from a visionary like Blake. Yet, the latter is also a great poet and a man who could use his hands. His very energy is like a laborer's. Blake is a painstaking worker, a craftsman or, rather, he is an artist of the Middle Ages whom a sudden mutation brought forth in England at the threshold of the Machine Age. He does not entrust his poems to the printer, but he writes them out and etches them, ornamenting them with floral motifs, like a master illuminator of long ago. He retraces the blinding visions that haunt him, his Stone Age Bible, his age-old spiritual antiquities of man, for the most part in a ready-made form, in the debased style of his own day — sad athletes with kneecaps and pectorals carefully drawn, heavy devices, Hell as found in Gavin Hamilton and in the studio of David. A vulgar respect for Ideal Form and for the aristocratic manner neutralizes his own profound idealism. Thus, we find spiritualists and amateur Sunday-painters both full of deference for the most worn-out academicism. All this is what we should expect: in them the soul kills the mind and paralyzes the hand.

We take refuge in Rembrandt. Is not his story one of a progressive liberation? His hand was first a slave to pleasing baroque festoons and mordents, then to a finely lacquered execution, but at length, toward the end of his life, his hand became master not

of an unconditioned freedom, nor of a greater virtuosity, but of
the necessary daring to take new risks. Simultaneously it takes
hold of form, tone and light. It brings the eternal hosts of shadow
into the daylight of living men. It piles up centuries in the pass-
ing of an instant. It evokes the grandeur of the unique in ordi-
nary men. To familiar things and to everyday dress it imparts the
poetry of the exceptional. It extracts fabulous riches from the filth
and weariness of poverty. How? Rembrandt's hand plunges to the
heart of matter to force it to undergo metamorphosis; one might
say that he submits it to the smelting action of a furnace, and that
the flame, lapping at these rocky plains, now calcines them, now
gilds them. It is not that the painter multiplies caprice and exper-
iment. He rejects curious procedures in order to travel boldly
along his way. But the hand is present. It does not indulge in mes-
merism. What it creates is not a flat apparition in empty space,
but a substance, a body and an organized structure.

By contrast, what an extraordinary proof of all this I once dis-
covered in some marvellous photographs which a friend brought
me from Suez! A clever and sensitive man in those parts had posed
some local rabbis before his camera. He cast about them effects
of light worthy of an old master. One would think that light ema-
nates from them, from their secular meditation in a shadowed
ghetto of Egypt. The foreheads bent over the wide-opened Tal-
mud, the noses of noble oriental curvature, the patriarchal beards,
the priestly cloaks with their fine folds – everything about them
suggests and affirms Rembrandt. Here indeed are his prophetic
old men, enthroned beyond time in the misery and splendor of
Israel. What discomfort, however, seized me in looking at these
incredibly perfect images! Here is Rembrandt minus Rembrandt.
Here is pure perception robbed of substance and density, or
rather, here is a dazzling optical souvenir, fixed in that crystal-
line memory which retains everything, the darkroom. Matter,

hand, man himself, are all absent. Such an absolute void in the
totality of presence is a very strange thing. Perhaps I have before
my very eyes an example of a future poetic expression; but as yet
I cannot people this silence and this waste land.

In considering masters who are full of warmth and freedom,
do we not, however, limit ourselves to a type, a group? Have we
banished from our reflections, as we might banish artisans with
a purely mechanical skill, those masters who with exquisite and
faultless patience have evoked more concentrated dreams from
choice materials and in refined forms? Is the hand of the engraver,
the goldsmith, the illuminator and the lacquerer merely an adroit
and complacent servant broken into the practice of fine work?
Is what we call perfection, then, the virtue of a slave? Working
in the smallest scope, sure of itself and of its direction, such a
hand has already become a prodigy, because it subjects the enor-
mous scale of man and of the world to the dimensions of the
microcosm. It is no mere device for reducing something. The
discipline of restricted size is less important to it than its own
capacity for action and truth. At first sight, the festivals and bat-
tles of Callot appear to be plates from a book on entomology,
migrations of insects in a landscape of molehills. In the *Siege of
La Rochelle*, are not the forts and the ships like toys? Numerous,
packed together, precise, complete in every detail, do they not
appear as if seen from the large end of an opera glass? Is it not
the marvel of this handmade thing that everything is understood
and ordered within the limits of a stage that is not only diminu-
tive but immense? Isolate any figure or any ship, examine it under
a magnifying glass and it appears not only in its simple grandeur,
its viability — while having lost nothing if brought up to normal
scale — but it is authentic. By this I mean that it resembles noth-
ing else, that it has the accent of Callot's own handwriting, the
inimitable line of his nervous elasticity, of that art of his which

is so attentive to the suppleness of clowns and tightrope walk-
ers, so like elegant fencing, so like the greatest violin playing.
Callot writes "with a clerk's hand," as was once said of calligra-
phers; he writes with the hand of a master — but this hand, so
proudly clever, never loses its sympathy for life or its ability to
evoke movement. In the ritual of perfection it preserves the sense
and practice of freedom.

Let us bend down over another enchanted world. Let us
examine at length, holding our breath, Fouquet's *Hours of Etienne
Chevalier* (Figure 24). Do we find here, caught beneath the frost of
a miraculous execution, absurdly perfect figurines rendered with
minute strokes according to workshop rules by an exceptionally
acute observer? Far from it. Here is one of the highest expres-
sions of that sense of monumental form which is the characteristic
trait of the French Middle Ages. One can enlarge these figurines
a hundredfold without their losing in power of projection or in
fundamental unity. They are like church statues, whose sisters or
descendants they might well be called. The hand that drew them
belongs to a dynasty formed by centuries of sculpture. It retains,
if one may say so, the bent and the force of sculpture even in the
tiniest bas-reliefs, dark and gilded, and painted like optical illu-
sions, which sometimes accompany the manuscript illumination
and which are likewise treated with exquisite breadth. Thus do
two worlds come together, as in the circular mirror that Van Eyck
hung at the back of the Arnolfini portrait: the world of living
giants, cathedral builders and image carvers, and the magical
world of the infinitely small. In one world, the hand works with
mallet and chisel on a block of stone propped up on a trestle; in
the other, it works over a square of parchment in which fine
instruments fashion the most precious rarities of the design. I do
not know whether one senses it, or if everything is done to make
us forget it; but the hand is there, making its presence known in

the joining of the limbs, in the energetic calligraphy of a face, in the profile of a walled city blue in the atmosphere, and even in the gold cross-hatchings that model the light.

Nerval relates the story of a hand laid under a curse and which, severed from its body, journeys over the world to do a work of its own. As for me, I separate hands neither from the body nor from the mind. But the relationships between mind and hand are not, however, so simple as those between a chief accustomed to obedience and a docile slave. The mind rules over the hand; hand rules over mind. The gesture that makes nothing, the gesture with no tomorrow, provokes and defines only the state of consciousness. The creative gesture exercises a continuous influence over the inner life. The hand wrenches the sense of touch away from its merely receptive passivity and organizes it for experiment and action. It teaches man to conquer space, weight, density and quantity. Because it fashions a new world, it leaves its imprint everywhere upon it. It struggles with the very substance it metamorphoses and with the very form it transfigures.

Trainer of man, the hand multiplies him in space and in time.

Figure 24. Fouquet: Detail from St. Paul on the Chemin de Damas.

Photo Credits:

Frontispiece: Reproduced by courtesy of the Trustees, The National Gallery, London

1. The Metropolitan Museum of Art, Rogers Fund, 1933.
2. Trinity College Library, Dublin.
3. The Metropolitan Museum of Art, The Cloisters Collection, 1925.
4. Alinari/Art Resource.
5. Sandak.
6. Harlingue-Viollet.
7. Giraudon.
8. The Metropolitan Museum of Art, Gift of J. Pierpont Morgan, 1917.
9. Zodiaque.
10. The Metropolitan Museum of Art, The Cloisters Collection, 1947.
11. The Metropolitan Museum of Art, The Cloisters Collection, 1954.
12. Alinari/Art Resource.
13. Giraudon/Art Resource.
14. The Metropolitan Museum of Art, Robert Lehman Collection, 1975.
15. The Metropolitan Museum of Art, Bequest of Lizzie P. Bliss, 1931.
16. Alinari/Art Resource.
17. The Metropolitan Museum of Art, Gift of Felix M. Warburg and his family, 1941.
18. The Metropolitan Museum of Art, Harris Brisbane Dick Fund, 1937.
19. The Metropolitan Museum of Art, Rogers Fund, 1941.
20. The Metropolitan Museum of Art, Bequest of Benjamin Altman, 1913.
21A. Los Angeles County Museum of Art, Gift of H.F. Ahmanson & Co., in Memory of Howard F. Ahmanson.
21B. Mauritshuis.
22. Ny Carlsberg Glyptotek.
23. Smithsonian Institution, Courtesy of the Freer Gallery of Art.
24. Giraudon/Art Resource.

Index

This edition designed by Bruce Mau
Type composed by Archetype
Printed and bound Smythe-sewn by Arcata Graphics/Halliday
using Sebago acid-free paper